3/91

AFRICAN-
AMERICAN
ARTISTS
1880-1987

AFRICAN-AMERICAN ARTISTS
1880-1987

SELECTIONS FROM THE EVANS-TIBBS COLLECTION

Guy C. McElroy
Richard J. Powell
Sharon F. Patton

Introduction by
David C. Driskell

SMITHSONIAN INSTITUTION TRAVELING EXHIBITION SERVICE
Washington, D.C.

In association with
UNIVERSITY OF WASHINGTON PRESS
Seattle and London

Published on the occasion of an exhibition organized by the Smithsonian
Institution Traveling Exhibition Service with the Evans-Tibbs Collection.

Library of Congress Cataloging-in-Publication Data

McElroy, Guy C.
 African-American Artists.

 Bibliography: p. 125
 1. Afro-American art—Exhibitions. 2. Art, Modern—19th
century—United States—Exhibitions. 3. Art, Modern—20th century—United
States—Exhibitions. 4. Evans-Tibbs Collection—Exhibitions. I. Powell,
Richard J., 1953- . II. Patton, Sharon F. III. Smithsonian
Institution. Traveling Exhibition Service. IV. Title.
N6538.N5M35 1989 704'.0393073'0074 88-600493
ISBN 0-295-96837-0 (cloth edition)
ISBN 0-295-96836-2 (paper edition)

COVER: Hughie Lee Smith,
Reflection,
oil on canvas, 1957
(fig. 43)

PAGES 2—3: Lois Mailou Jones,
Detail of *The Lovers (Somali Friends)*,
casein on canvas, 1950
(fig. 26)

BACK COVER: Betye Saar,
Dat Ol' Black Magic,
mixed media, 1981
(fig. 67).

FRONTISPIECE: Raymond Saunders,
Detail of *Red Star*,
oil on canvas, 1970
(fig. 58)

CONTENTS

ACKNOWLEDGMENTS

Social and political events of the past 150 years have exerted a powerful influence on the emergence of African-American art as a distinct form of expression. This book, which accompanies the exhibition *African-American Artists 1880-1987: Selections from the Evans-Tibbs Collection*, looks at the effects of Reconstruction, the Harlem Renaissance, the Federal Works Progress Administration, and the civil rights movement, to name a few, as potent forces that have shaped black artists and the art they have created.

The Evans-Tibbs Collection, from its earliest incarnation as an informal salon, has been an influential part of this milieu for many years. We wish to thank Thurlow Tibbs for so graciously lending works from his collection to SITES, so that they may be shared with audiences across the country. He has continued the family tradition of collecting African-American art begun by his grandmother Lillian Evans Tibbs (popularly known as Madame Lillian Evanti), whose home—where the works were first hung in the 1920s—became a gathering place for black artists and

intellectuals. Now a gallery operated by her grandson, the stately Victorian row house, just off Logan Circle in our nation's capital, has won a well-deserved spot on the National Register of Historic Places.

The collection itself numbers hundreds of works of art and thousands of bibliographic entries; at Evans-Tibbs, we would like to acknowledge registrar Roderick Williams, who provided invaluable support in assembling this exhibition, and to extend our gratitude to Kathleen Halley, who gave essential curatorial assistance.

We particularly wish to thank the four scholars whose words inform this catalogue, all of whom have devoted much of their careers to the study of African-American art and artists. The works shown herein could not have been developed into an exhibition without their expertise. Dr. David Driskell of the University of Maryland, himself an artist who figures prominently in the story told in these pages, wrote the introduction. Guy C. McElroy, guest curator at The Corcoran Gallery of Art, Washington, D.C., provides fresh insight into the work of the African-American art-ists who reached maturity during the turbulent years of the Civil War, Reconstruction, and the Progressive Era. Richard J. Powell, program director at Washington Project for the Arts, examines the middle period, 1920 to 1950; by his acute observations, readers come to understand the complicated cross-currents of this pivotal period, when African-American artists committed themselves to instilling racial pride, examining social ills, and exploring indigenous folk roots. Sharon F. Patton, chief curator at the Studio Museum in Harlem, devoted enormous energy to the research and interpretation of recent trends in black art, beginning in 1950; she has accomplished the arduous task of placing the evolving styles of the time into the context of the sometimes explosive events surrounding them.

We are also extremely grateful to our colleagues at the Smithsonian Institution Traveling Exhibition Service, without whose talents this project could not have been realized: Anna Cohn, director; Linda Bell, assistant director for administration; Andrea Stevens, publications director; Myriam Springuel, curator of education; Lee

Williams, head registrar; and Fredric P. Williams, associate registrar.

We would also like to thank the staff of the Office of Exhibits Central, Smithsonian Institution, for their steady hands in editing the script and designing the exhibition. Karen Fort and Walter Sorrell supervised production; Marian Menzel designed the exhibition; Diana F. Cohen edited the script; Pat Burke, Ken Clevinger, and Rick L. Yamada produced panels and labels and packed the exhibition.

Three individuals should be singled out for their contributions to this project. In the early phases, Frank Mitchell, a research associate from Yale University, devoted an entire summer at SITES to preliminary exhibition organization and financial development. The exhibition would not have been the same without him. Penni Billett assisted in every aspect of the project, from development through production; her ability to unravel miles of red tape was an inspiration to us all. Dale E. Alward, editor, brought his full palette of skills to bear on this catalogue; his signature is evident on every page.

The Evans-Tibbs Collection has received invaluable support from the Expansion Arts Program of the National Endowment for the Arts, the District of Columbia Humanities Council, and the District of Columbia Commission on the Arts and Humanities. Research for this book was funded by the District of Columbia Humanities Council. We are grateful to the University of Washington Press for its commitment to distributing the book to the broad audience its subject commands.

Most of all, we thank the artists themselves, without whose works this exhibition would not have been possible. Their art continues to inspire and touch us, over the span of many decades.

GERMAINE JUNEAU
Project Director
Smithsonian Institution Traveling Exhibition Service

INTRODUCTION

The art scene in our nation's capital has always been unique in that, unlike New York City, one could not identify one particular part of the city as Washington's "gallery district." Today, many galleries are scattered around the city while some have concentrated in the Seventh Street corridor and in the vicinity of Dupont Circle.

Art in Washington has played an important role in defining the broad cultural spectrum which includes an active community in music, dance, and theater, and there has always been a lively exchange among the patrons of these media. For the visual artist, seldom was there any great pressure to sell work by gallery hopping—taking portfolio into hand and wandering from place to place in search of the "right" gallery for one's work. Instead, a cordial and friendly atmosphere has existed over the years whereby one could be invited to exhibit without the usual fanfare or specialized gallery submissions.

This humanistic rite of passage for artists into the Washington art gallery scene has been aided in recent years by the fine work of the Evans-

Tibbs Collection. Nestled in the heart of the Shaw district, this rare gem of artistic excellence presents an important and growing collection of quality work by African-American artists. Yet it does not stand alone. The Evans-Tibbs has had very prominent models whose influence has helped chart the collection's course in what has now become an ever increasing community of superb art galleries and art related institutions in metropolitan Washington.

In the Evans-Tibbs style one can see the influence of these important models. The celebrated Phillips Collection, located ten blocks away, offers a home-like atmosphere where every serious student of the arts spends many hours. The Barnett Aden Gallery has for four decades provided quality leadership in the visual arts with constant exhibitions and occasional poetry readings whereby one could meet distinguished artists of all races in an intellectual atmosphere. And more recently, the Smith-Mason Gallery has functioned as an important link to the artist who teach in the public schools of the District of Columbia.

Now in its eleventh year of offering success-

ful exhibition programs, the Evans-Tibbs Collection has inherited the mantle of providing the salient leadership these small private galleries gave this city over many past decades. Its mission has been broadened in recent years to include the choosing and sharing of important exhibitions of work by African-American artists with other institutions around the nation.

Located in an important architectural district in the U Street corridor, the 1894 house was the home of Lillian Evanti, America's first black opera star to gain international recognition. Today, the collection is under the able direction of the young grandson of Madame Evanti, Thurlow Tibbs. Educated at Dartmouth and Harvard, Tibbs exercises an important voice in the Washington art community. He has carried on a tradition of excellence in his choices of exhibitions and his selection of artists and scholars who have been in residence at the collection. Significantly, he has brought to the attention of the Washington art community the art of black America in its finest form. And to this testimony nothing attests more poignantly than this exhibition which has been

selected in its entirety from the more than 400 holdings of the growing collection.

The primary purpose for the Evans-Tibbs Collection remains that of referencing and exhibiting works of art by African-American artists of the nineteenth and twentieth centuries. That is a task made much easier thanks to the collection's vast reference archive which numbers more than 11,500 entries of bibliographic data. The art one views there can be readily referenced in matters of provenance and historical significance through modern technology and current files—a feat not always enjoyed or even possible at some of our larger and more prestigious institutions. More importantly, the cultural services that the Evans-Tibbs Collection renders the city of Washington and indeed the nation are professionally sound. They elicit our patronage and are worthy of national and international attention. This, one hopes, is to be forthcoming.

DAVID C. DRISKELL
Professor of Art
University of Maryland, College Park

THE FOUNDATIONS
FOR CHANGE
1880-1920

Guy C. McElroy

Detail of *Patio*
William Harper,
oil on canvas, 1908
(fig. 12)

The African-American artists who reached maturity following the Civil War experienced the broadened opportunity afforded by emancipation but suffered the ostracism and limitations imposed by new forms of institutionalized racism. While these artists often had the advantage of studying in leading American fine arts centers, their limited access to patronage and the broader cultural milieu frequently made it impossible for them to realize the status of their white contemporaries. The post-Civil War movement of blacks from the rural South to the urban North eventually resulted in the concentration of African Americans in major cities such as Baltimore, Philadelphia, Boston, New York, Washington, Atlanta, and, in the West, San Francisco. It was in these cities that an educated black middle class developed. And it was also here that African-American artists found endorsement and support from a small number of the enlightened white middle class, many of whom had been involved in abolitionist activities.

Some black artists overcame limitations to achieve regional and even international acclaim. Edward Mitchell Bannister (1828-1901) of Rhode Island won a gold medal for his *Under the Oaks* (now lost) at the 1876 Centennial Exposition in Philadelphia. Bannister became a respected member of the arts community in Boston and Providence. Henry Ossawa Tanner (1859-1937), a student of Thomas Eakins, followed a different route. Tanner became an expatriate and lived in France, where, beginning in the early 1890s, he exhibited regularly at the Paris Salon. The extent of his notoriety is evidenced in his appointment as a chevalier to the French academy. Tanner was considered the dean of American painting during his lifetime, and his reputation at the time exceeded that of his now celebrated teacher, Eakins.

African-American artists assimilated the major styles dominating late nineteenth- and early twentieth-century American art and demonstrated an ability to create works of art equivalent to (and in some cases surpassing) those of their more advantaged mainstream colleagues. Edward Mitchell Bannister became a consummate landscapist, creating intimate landscapes influenced by the Barbizon School. Grafton Tyler Brown (1841-1918) created lithographs and paintings depicting spectacular views of western landscapes in which the stylistic concerns of the later Hudson River School are evidenced. Nelson Primus (1843-1916?), a New England painter, executed portraits and religious paintings, which gained him recognition in Boston. Tanner's genre paintings and brilliant biblical tableaus embodied the best qualities of French academic painting and impressionist-influenced color. The works of his students, William A. Harper (1873-1910) and William Edouard Scott (1884-1964), reflect a diversity of stylistic influences. While Harper created subtle Barbizon-influenced landscapes, Scott produced paintings that exhibit a growing concern for black subject matter and a freer use of color—a quality that would later become characteristic of the artists of the Harlem Renaissance. Finally, the distinctive work of photographer Addison Scurlock (1883-1964) depicted with skill and sophistication the lives of the African-American middle class in America's urban centers, particularly those in Washington, D.C.

The works by the preceding artists assembled in the Evans-Tibbs Collection provide an opportunity to review the development of African-American art and artists during a period of turbulent historical and cultural change. A close examination of their varied achievements will illuminate the extent of their talent, and the beauty and quality of their art.

The career of Edward Mitchell Bannister exemplified the opportunities available to the African-American artist as a result of abolitionist activities in the Northeast. Bannister was born in St. Andrews, New Brunswick, where he began studying art informally. In 1848, he relocated with his brother to Boston, where he worked at menial jobs before gaining employment as a barber. By 1857, he had married Christiana Carteau, an owner of stylish hair salons. Valued for his skill as a painter and his pleasant personality, Bannister gained access to the abolitionist circles in Boston that would be crucial to the development of his artistic career.

Bannister's developing skills were evident in the landscapes and seascapes he produced in the mid-1850s. A decade later, he had taken a studio

Fig. 1 | **Edward Mitchell Bannister**
Landscape with a Boat
oil on canvas
1898
cat. 2

THE IRON CLAD MINE.

1½ MILES BELOW

ROUGH & READY, NEVADA CO. CAL.

Fig. 2 | **Grafton Tyler Brown**
The Iron-Clad Mine
lithograph
about 1880
cat. 14

Fig. 3 | **Grafton Tyler Brown**
Yosemite Falls
oil on canvas
1888
cat. 1

and began studying at Boston's Lowell Institute with the noted American sculptor William Rimmer. Bannister's efforts to develop his talent were inspired further by an inflammatory statement in an 1867 issue of the *New York Herald* suggesting that African Americans were able to appreciate art, but unable to produce it.

In his early works, Bannister evidenced a romantic style probably influenced by the paintings of the French Barbizon artists, whose works he may have seen at the Boston Athenaeum. He would also have been aware of the painterly style of William Morris Hunt, who was active in Boston and Newport, Rhode Island, at the time.

By 1870, Bannister had relocated to Providence where he became an active member of the developing art scene. In 1876, when he arrived at the Philadelphia Centennial to claim his first place bronze medal for *Under the Oaks*, Bannister was met by a shocked crowd of onlookers and officials who were unprepared to accept the fact that a black artist had executed the award-winning entry.

Bannister experimented with painted landscapes, still lifes, and genre scenes, but eventually concentrated his efforts on the depiction of the New England landscape, particularly the area around Providence. In the 1870s and 1880s, Bannister painted rolling hills and idyllic forested glens, as well as seascapes with humid, cloud-filled skies. The dense impasto and limited palette he employed may be closely associated with such Barbizon artists as Corot, Daubigny, and Diaz.

As he reached maturity as an artist, Bannister reduced his painterly means in favor of a very suggestive and evocative style. The 1898 *Landscape with a Boat* (fig. 1) is from this period. In this delicate work, the artist uses a palette of closely graduated color. The rich greens and subtle

modulations of the landscape and water contrast with the creamlike grays and blues of the sky. Detail is subjugated to achieve an overall unity. A dreamlike quality, typical of many of Bannister's works from this period, pervades the canvas.

Bannister's status as a respected member of the Providence artistic establishment was evidenced by the respect with which he was held. He exhibited widely in the city, and in the 1880s was one of the founding members of the Providence Art Club. Upon his death in 1901, Bannister was given a memorial exhibition, and his colleagues erected a monument in his name.

The art and life of Grafton Tyler Brown contrasts sharply with that of Bannister. Although he was born in Harrisburg, Pennsylvania, Brown chose to live in the Pacific Northwest, where he was inspired by the overwhelming natural beauty of the landscape.

By 1861, Brown had moved to San Francisco where he was employed as a draftsman and lithographer for Charles Kuchel. It was here that Brown learned to paint and make lithographs. His works of this period include spectacular Northwest mountain landscapes, as well as the small mining towns characteristic of the region. The lithographs he produced for the Kuchel Company include street maps, views of mining towns, stock certificates, letterheads, and sheet music. Upon the death of Mr. Kuchel in 1866, Brown continued to manage the company for Mrs. Kuchel. In 1867, he opened his own business in San Francisco.

In the late 1870s, Brown sold his business and began traveling throughout the Pacific Northwest, probably maintaining a residence in Victoria, British Columbia. In 1883, he exhibited works in the offices of *The Colonist,* which included twenty-

Fig. 4 | **Nelson Primus**
Portrait of a Lady (Lady with Golden Hair)
oil on canvas
1907
cat. 3

two views of British Columbia scenery. His works were praised for both their beauty and their fidelity to the familiar landscape.

Brown's continuing experience as a lithographer undoubtedly contributed to the meticulousness of his style. Beginning in the early 1890s, he worked as a draftsman for the United States Army Corps of Engineers and eventually relocated to St. Paul, Minnesota. It was probably during this period that the artist began to travel extensively throughout the West. His style developed from the detailed but simple and planar rendition of landscapes as evidenced in *The Iron-Clad Mine* (ca. 1870s; fig. 2) to the more fully realized spatial relationships and rich color of his works of the 1880s, as in *Yosemite Falls* (1888; fig. 3).

Brown's later landscapes exhibit the predilection for magnificent views and carefully subjugated detail found in the works of Thomas Moran, whose paintings and lithographs of the Grand Canyon and other western scenery may have influenced him. In *Yosemite Falls*, the bold verticals of the foreground, the craggy cliffs, and the delicate sweep of the falls form a unity that inspires the viewer. Brown's dramatic landscapes and seascapes undoubtedly contributed to the growing public awareness of the nation's natural resources.

Born in Hartford, Connecticut, Nelson Primus was a contemporary of Bannister's in Boston. Unfortunately, his success was more limited than that of Bannister and Brown. In fact, he complained of Bannister's reluctance to share his entrée into Boston's white abolitionist circles.

Unlike the two landscapists, Primus specialized in portraiture and paintings of religious themes. Though well received in Boston, his portraits did not provide him with financial success. The 1907 work, *Portrait of a Lady (Lady with Golden Hair)* (fig. 4), suggests both the artist's skills and limitations. The careful manner of this painting and its stringent attention to detail may suggest that Primus used photographs to capture the likeness of his model. The warm color of the subject's skin and the brilliant tones of the carefully rendered hair contrast with the darker ground.

The unfortunate loss of most of Primus' works and limited documentation of his life allow us little opportunity to further explore the nature of his existence and the quality of his art. What is apparent is the limited access to Boston's elite that circumscribed his opportunities for wider success.

Henry O. Tanner achieved notoriety on both sides of the Atlantic. Born the son of a distinguished black minister, Tanner had the opportunities for education and cultural development afforded few African Americans. At age 13, he determined to pursue a career as an artist, a decision which was not encouraged by his more practical-minded parents. Tanner's youth was fraught with negative experiences caused by racial tensions, and his efforts to obtain artistic instruction from members of Philadelphia's white artistic community met with frustration.

These experiences, however, did not deter Tanner from pursuing his development as an artist. Tanner's brief attempt to pursue a career as a tradesman was thwarted by an illness he contracted as a youth. This experience probably convinced his parents to permit him to pursue his objective of becoming an artist.

For several years he worked independently, finally enrolling in the Pennsylvania Academy of Fine Arts in 1880, where he studied until 1882. It was here that he met Thomas Eakins, the celebrated realist and portrait painter, from whose instruction he developed a careful knowledge of anatomy and an ability to create penetrating psychological studies of his portrait subjects. Eakins became a friend and in 1902 painted a portrait of Tanner which is now in the Hyde Collection (Glens Falls, New York).

Following his formal studies at the Pennsylvania Academy, Tanner was unsuccessful in his attempt to pursue a career as an artist in Philadelphia and later as a photographer in Atlanta. He taught briefly at Clark College in Atlanta and, with the assistance of Bishop Joseph Hartzell, mounted an exhibition of his works in Cincinnati. Sensitive to Tanner's need to escape the repressive environment of late nineteenth-century America, the Hartzells purchased the paintings from Tanner's Cincinnati exhibition, which permitted him to leave the United States for Paris in 1891.

It was probably the influence of Eakins that led Tanner to study at the Academy Julien, where he was instructed by Jean Joseph Benjamin-Constant and Jean Paul Laurens. Tanner's work from this period would eventually reflect the precise line and rich coloration characteristic of French academic painting.

Tanner's studies of black subjects, executed in the Adirondacks prior to his arrival in France, served as a basis for the genre paintings he painted in the early 1890s. In works such as *The Banjo Lesson* (1893; Hampton University) and *The Thankful Poor* (1894; private collection), the artist created works of intense emotional depth and rich sentiment that transcend the saccharine quality

apparent in the genre work of his contemporaries.

The 1895 painting *The Young Sabot Maker* (collection of Sadie T.M. Alexander, Philadelphia) signalled Tanner's movement to French subjects for his paintings. It was also at this time that the artist began to focus his attention on religious painting. His success was evidenced in such paintings as the 1896 *Daniel in the Lion's Den,* which received an honorable mention at the Paris Salon, and *The Raising of Lazarus,* which was purchased by the French government. Encouraged by these honors, Tanner devoted the remainder of his career to painting and etching biblical subjects or scenes from the Holy Land.

Beginning in 1897, Tanner made several journeys to the Near East. As a result of these trips his palette grew lighter and his canvases became filled with the inspiration and specific detail culled from his travels. Further, a new sensitivity to creating effects of mood with vibrant color—probably influenced by the impressionists—entered his canvases.

In 1899, Tanner painted *Head of a Girl in Jerusalem (The Artist's Wife)* (fig. 5). In this work, the expressive face of a young woman is defined by an animated line and a rich orange-gold color with white highlights. Tanner's increasing use of a monochromatic palette, as well as his fascination with the individuals he saw in Jerusalem, is evident in this work. His mastery of characterization can also be seen in the animated expression of surprise evident in the woman's face.

In addition to being regarded as a major painter in both France and the United States after 1900, Tanner was also a skillful etcher. In etchings such as *Street Scene—Tangiers* (1913; fig. 6) and *Gate—Tangiers* (1910; fig. 7), the artist utilizes delicate line and careful cross-hatching to create

Fig. 5 | Henry O. Tanner
Head of a Girl in Jerusalem (The Artist's Wife)
oil on artist board
1899
cat. 5

Fig. 6 | **Henry O. Tanner**
Street Scene–Tangiers
etching
1913
cat. 8

Fig. 7 | **Henry O. Tanner**
Gate—Tangiers
etching
1910
cat. 9

Fig. 8 | **Henry O. Tanner**
Christ Walking on the Water
etching
1910
cat. 10

the effect of sun-drenched environments. These works are comparable to canvases of the same period in which brilliant light dissolves form to create patterns of light and shadow rather than detailing reality. Tanner's 1910 images *Street Scene, Tangiers, Man Leading Calf* and *Palais de Justice, Tangiers* (both in the collection of the National Museum of American Art) are comparable to these vibrant etchings.

Produced in the same year, the etching *Christ Walking on the Water* (fig. 8) also illustrates the effect of light and shadow dissolving form and the profound spirituality apparent in Tanner's religious paintings. In this work, Tanner uses curving lines to capture the heaving motion of the boat. Christ's Apostles look toward the horizon where the fugitive figure of Christ appears against a white background.

The same sensitivity to line and light is evident in the 1913 etching *The Wreck (Shipwreck on the Coast of Brittany)* (fig. 9). Here the luminous seashore and agitated waves of the ocean contrast with the dark hulk of the grounded boat. In the background, Tanner utilizes cross-hatching and fragile lines to recreate a distant view of a village and boats on the inlet. In a manner different from his more evanescent religious work, Tanner carefully and naturalistically records this scene from nature.

The artist's use of evocative color to establish mood is readily apparent in *After the Storm* (ca. 1880, attributed to Tanner; fig. 10) and *The Good Shepherd* (ca. 1918; fig. 11). In both works, the artist again utilizes a monochromatic palette to obtain expressive effect.

After the Storm captures the still moments following a storm at sea which has wrecked the foundering boat at the left. The rose and gold tint of the calm sky in the upper right contrasts with the dramatic deep blues of the still agitated ocean. Tanner's unique glazing technique lends itself especially well to the depiction of turbulent seas.

In *The Good Shepherd*, the artist also employs thin layers of glazes to create vibratory light effects. The image of the shepherd surrounded by sheep is more suggested than defined. In this and comparable late works, Tanner's preoccupation with the effects of light and shadow leads to imagery in which the artist's preoccupation is more with technique than with his subject.

Tanner remained in France until his death in 1937. Though he gladly welcomed young black artists to his studio and offered them guidance and instruction, he remained separate from developments in politics and the visual arts and eschewed the new styles of painting in the United States and France.

Two of the artists who found their way to Tanner's Paris studio were William Harper and William Edouard Scott. Harper was a transitional figure whose brief life only suggested his potential as a practitioner of the modernist styles that evolved in France. Unlike their teacher, both Harper and Scott experimented with the more brilliant palette and painterly techniques that characterized French painting of the period. Scott, a somewhat younger artist, would later be influenced by the French Fauves. He would also develop an interest in depicting black subjects which would be so much a part of the focus of the Harlem Renaissance. The pattern of both artists' lives is one that many African-American artists after Tanner would adopt: initial studies in the United States followed by the relocation to Europe for further study and greater artistic freedom.

Fig. 9 | **Henry O. Tanner**
The Wreck (Shipwreck on the Coast of Brittany)
etching
1913
cat. 7

Fig. 10 | **Henry O. Tanner**
After the Storm
oil on canvas
about 1880
cat. 15

Fig. 11 | **Henry O. Tanner**
The Good Shepherd
oil on artist board
about 1918
cat. 6

Born in Canada, Harper moved to the United States to study at the Art Institute of Chicago. A brief apprenticeship to Tanner in Paris followed, and it was undoubtedly with this experience that Harper developed the basis for his landscape style. In his studies of the French countryside, Harper captures an idyllic and pastoral mood, building his canvases with broadly applied pigment. In works such as *Landscape with Poplars (Afternoon at Montigney)* (ca. 1898; collection of the Gallery of Art, Howard University), Harper's debt to the Barbizon painters is apparent in the intimate setting and the dense impasto of close color values.

Harper's travels included England, Mexico, and France, where he painted in Provence and Brittany. While his choice of subject was conservative, his treatment indicated a sensitivity to newer ideas. The European landscapes exhibited in Chicago were widely praised. Art historian Alain Locke described Harper as one of the finest artistic talents to emerge in the late nineteenth century. His unfortunate death while sketching in Mexico deprived American art of one of its most promising talents.

The 1908 work *The Patio* (attributed to Harper; fig. 12) demonstrates the artist's ability to capture a fleeting moment of a light-filled afternoon. Harper summarily depicts a courtyard with a figure seated before a table. A group of chickens scurries nearby, and bright sunlight pours through the arched entryway. The painting is a composite of modulated whites, cool grays, and blues. This canvas, with its quick evocative brush strokes, suggests Harper's apparent awareness of impressionist techniques.

William Edouard Scott's career foreshadowed the wider opportunities which would become available to the African-American artist during the Harlem Renaissance, beginning in the mid-1920s. Scott also studied at the Art Institute of Chicago, and by 1912 he journeyed to Paris where he studied with Henry Tanner as well as at the Academy Julien and Academy Colarossi.

Scott's canvases include genre scenes, portraits, and character studies. Among his works are colorful depictions of Haitian life, careful studies of African Americans, and subjects inspired by his stay in France. The acceptance of Scott's paintings at the Paris Salon and in England at the Royal Academy demonstrate his success in Europe. In the United States, his efforts to improve and develop his art were supported by the Harmon Foundation and the Rosenwald Foundation—organizations whose assistance afforded crucial funding to black artists emerging in the 1920s and 1930s. Scott's early interest in portraying African-American subjects was probably further encouraged by the forceful rhetoric of such promoters of the Harlem Renaissance as Locke and sociologist Charles Spurgeon Johnson.

With a grant from the Rosenwald Foundation, Scott traveled to Haiti in 1931, where he created numerous paintings depicting the Haitian people. The burning color and bold brushwork of these pieces indicate Scott's response to the high-keyed palette of the Fauves, whose works would have been available to him during his stay in Paris. These brilliant canvases celebrate Haitian life, and at the same time are sensitive depictions of grave characters on whose faces a painful story of life can be read. Scott exhibited his Haitian studies at Port-au-Prince, where they received the acclaim of the Haitian government.

Scott was an excellent draftsman as well as a skillful painter. His lithographs show a sensitive

Fig. 12 | **William Harper**
Patio
oil on canvas
1908
cat. 4

use of light and shadow that implies a wide range of tonal value. Two works dated 1912 illustrate the artist's versatility in this medium. *Old Woman* (fig. 13) depicts a melancholy aged subject wrapped in a muffler, her collar pulled up. In the play of delicate line and shadow, which partially obscures her face, the artist evokes a timeworn expression. This work is closely related to paintings of a similar theme Scott executed in France; *La Pauvre Voisine,* for example, also depicts the loneliness and dejection of old age.

In another work entitled *Lagoon* (1912; fig. 14), Scott recreates in subtle grays a watery inlet with a delicate bridge. The composition is almost Whistlerian in its reduction of the landscape to basic forms and tones. The dark fluid horizontals of the shore create a rhythm with the simple rounded gray forms of the low hills on the horizon, a pattern lightly repeated in the washes of the sky. The composition recalls the allusive quality of a Japanese print.

While black painters were involved in the creation of works which reflected the response of their imaginations to the outside world, African-American photographers were involved in documenting the lives of the black middle class that had sprung up in America's cities. After the turn of the century, the pace of African-American relocation to urban cities increased markedly. By the second decade of the new century, the lives of African Americans in the major cities had reached a heretofore unprecedented diversity and richness. Urban areas of the North and South experienced unprecedented growth. New York City boasted the largest population of African Americans, concentrated within the borders of Harlem, where Alain Locke's "New Negro" was creating new forms in music, literature, and the visual arts. The same energy was apparent in southern cities such as Washington, which was the center of an educated black elite.

Accomplished black photographers found careers portraying emerging black leaders and community members, as well as documenting their pleasures and pastimes. In New York, James Van DerZee captured the scintillating life of black Harlem. In Washington, Addison N. Scurlock depicted the city's cultivated and accomplished black society. Scurlock's skillful portraiture helped draw to Washington African Americans of national fame, such as the scholar W.E.B. DuBois and poet Paul Laurence Dunbar.

Born in Fayetteville, North Carolina, Scurlock moved to Washington in 1900 where he worked as an apprentice at the Rice Studio on Pennsylvania Avenue. By 1911, he had opened his own photographic business, which he maintained until 1964.

In Washington, Scurlock found a large clientele. The city boasted innumerable churches, black civic organizations, and clubs. Howard University was a center for the city's black intelligentsia, in which Scurlock found eager sitters. The presence of the federal government with it numerous minor black bureaucrats also generated customers interested in preserving their countenances for posterity.

To this large and diverse community, Scurlock brought his unusual skills as a photographer. His works mirror a sophisticated understanding of photographic techniques, as well as an artist's skill at composition and lighting. Scurlock was challenged by the limitations of equipment and poor lighting, and his ability to capture his

subject was unsurpassed. His numerous views of events and activities in Washington and its environs are characterized by carefully balanced composition, painterly use of light, and a crispness of detail.

Official photographer for Howard University from the 1900s to 1954, Scurlock's works were published widely, and he received awards for their excellence. His well-balanced portraits reveal the mood and dignity of his sitters and are permeated by a glowing light which seems to radiate from within each subject. It is no wonder that he was so widely sought after and recognized.

Scurlock's *Portrait of Mrs. Johnson* (1905; fig. 15) exemplifies the photographer's skill early in his career. Positioned in monumental three-quarter pose, Mrs. Johnson bears a dignity and unusual force of character. Reworking the photograph, Scurlock has carefully highlighted her face and softened her features. The bold play of light and dark in the detail of her dress, with its velvet collar, is accentuated with curving line. Obviously, Scurlock was not content to merely represent his subject, but tried to recreate the effects of a painted portrait in this careful study.

Living and working within a context of socially enforced limitations, African-American artists of the period 1880 to 1920 surprisingly survived and in some cases flourished. Each found his way to an artistic education equivalent to that of many of his mainstream peers. In the major cities of the United States, black artists frequently found encourage-

ment and patronage. While Bannister, Brown, and Primus, born in the first half of the nineteenth century, pursued their entire careers in the United States, Tanner and those artists who succeeded him were able to find new freedom and broader experience in Europe, setting a pattern which would be followed by African-American artists later in the twentieth century. Although only Tanner would become internationally renowned, others active at this time would be exhibited extensively and receive the admiration and respect of their colleagues. Black artists became skilled practitioners of the styles and techniques which were prominent during this period. While the older artists remained conservative in their adherence to the widely accepted styles of the late nineteenth century, in the works of the younger painters is seen an openness and willingness to experiment. Undoubtedly, the fact that it was necessary for black artists of the nineteenth century to appeal to a mainstream audience led them to portray black subjects infrequently. This circumstance was changed in the twentieth century with the growth of a black middle class and the development of a new black awareness which resulted in the incorporation of black subject matter into the art of African Americans working in the second decade of the new century. This consciousness is further seen in the documentation of African-American life found in black photography, particularly that of Addison Scurlock. The works of these pioneers set the stage for the artists of the Harlem Renaissance, in whose work a new vigor and self-determination would result in an art concerned with a black identity.

Fig. 13 | **William Edouard Scott**
Old Woman
lithograph
1912
cat. 13

Fig. 14 | **William Edouard Scott**
Lagoon
lithograph
1912
cat. 12

Fig. 15 | **Addison Scurlock**
Portrait of Mrs. Johnson
photograph with highlights
1905
cat. 11

SOURCES

Corcoran Gallery of Art, *Addison N. Scurlock* (Washington, DC: Corcoran Gallery of Art, 1985).

Dover, Cedric, *American Negro Art* (Greenwich, CT: New York Graphic Society, 1969).

Driskell, David C., *Two Centuries of Black American Art* (New York: Los Angeles County Museum of Art and Knopf, 1976).

The Evans-Tibbs Collection, "Grafton Tyler Brown, Nineteenth-Century American Artist" (Washington, DC: The Evans-Tibbs Collection, 1988).

Fine, Elsa H., *The Afro-American Artist: The Search for Identity* (New York: Holt, Rinehart & Winston, 1973).

Hartigan, Lynda R., *Sharing Traditions: Five Black Artists in Nineteenth-Century America* (Washington, DC: Smithsonian Institution Press, 1985).

Igoe, Lynn M., *Two Hundred and Fifty Years of Afro-American Art: An Annotated Bibliography* (New York: R.R. Bowker, 1981).

Lewis, Samella, *Art: African American* (New York: Harcourt, Brace, Jovanovich, 1978).

Locke, Alain L., *Negro Art: Past and Present* (Washington, DC: Associates in Negro Folk Education, 1936).

Porter, James A., *Modern Negro Art* (New York: Dryden Press, 1943; repr. New York: Arno Press, 1959).

FROM RENAISSANCE
TO REALIZATION
1920-1950

Richard J. Powell

Detail of *Girl in a Red Dress*,
Charles Alston,
oil on canvas, 1934
(fig. 24).

The art of black Americans underwent numerous changes between 1920 and 1950. These changes in aesthetic points-of-view and degrees of racial and cultural consciousness can be attributed to the ideological shifts within black America as a whole. It was in this period that African Americans experienced spells of heightened self-awareness and optimism about the future, as well as moments of despair and disillusionment concerning their role in American society. Black migration from the rural South to the urban North, the stock market crash of 1929 and the resulting, worldwide economic depression, the encouraging governmental policies of Franklin Delano Roosevelt, and the social challenges which World War II brought about—all these events figure into black artistic expression during this period. Even in the many instances when the works avoid overt references to the political and social conditions of the day, America's attitude toward blacks is an everpresent backdrop for individual acts of art-making.

The initial part of this thirty-year period—roughly 1920 through 1935—has been described by various scholars as a time of rediscovery and of wide popularity for African-American culture. Although black Americans have consistently produced art and culture over the last several hundred years, the 1920s and early 1930s heralded an almost overwhelming outpouring of black artistic talent. Around 1926 this abundance of African-American art had as much to do with a general openness and curiosity on the part of the major arbiters of taste as it had to do with a mood of progress and optimism in black communities across America.

In the visual arts, blacks were encouraged to seriously pursue careers because of several, unprecedented phenomena: the almost simultaneous emergence in New York, Washington, and other cities of the community-sponsored, all-Negro art exhibition; the inauguration of several national award programs for excellence among blacks in the visual arts field; and the appearance in 1925 of *The New Negro*, a published collection of essays, short fiction, poetry, and illustrations, edited by Howard University professor Alain Locke. *The New Negro* called for, in manifesto form, a celebration of black America through the arts and letters.[1]

In the Evans-Tibbs Collection, several works of art from the 1920s and early 1930s encapsulate the ideals and sentiments of this "Negro Renaissance." The charcoal and pastel drawing of Harlem schoolteacher Harold Jackman (fig. 16) by Richmond Barthé (b. 1901) is not only a portrait of a specific person, but also a kind of *symbolic* portrait of an idealized black—someone sleek, urbane, and superficially attractive. Like the paintings and sculptures of many American artists during the 1920s, Barthé's drawing is wedded to a realist tradition that, despite the strains of cubism

and expressionism among a few avant-garde artists, was the primary stylistic mode of the day.

Although not considered an example of serious art in the 1920s, the photograph *Alpha Phi Alpha Basketball Team* (fig. 17) by New York commercial photographer James Van DerZee (1886-1983) captures a comparable mood of urban sophistication and self-possession. Van DerZee's photograph is as stylized and self-conscious as Barthé's portrait, and their shared objective—to depict the Negro in refined, socially acceptable terms—would not have been lost on the critics and social experimenters of the New Negro movement.

An artist who did not always fulfill the movement's mandate for uplifting and forward-looking images was Palmer C. Hayden (1893-1973). Known especially for his genre paintings of urban and rural black folk, Hayden adopted a humorous point of view which, when combined with a markedly expressive technique, communicated an earthy, theatrical, and often absurdist conception of African-American culture. *Café L'Avenue* (1932; fig. 18), a watercolor done by Hayden after a lengthy sojourn to France in the late 1920s, illustrates the artist's satirical perspective on humanity, regardless of race. The subject of *Café L'Avenue*—a brooding, alcohol-imbibing, middle-aged man—has the air of an *artiste*, as evidenced in the suggestions of a musical performance which envelops him. The man's exact features and the somewhat caricatured treatment of him suggest that this watercolor may, in fact, be a portrait of an actual person. But Hayden's surviving relatives and sketchy records do not supply much information beyond the watercolor's title and the certainty that, in this and other works, Hayden was guided by an animated and ironic sense of the world.

Fig. 16 | **Richmond Barthé**
Portrait of Harold Jackman
charcoal and pastel on paper
1929
cat. 38

Fig. 17 | **James Van DerZee**
| *Alpha Phi Alpha Basketball Team*
| *photograph*
| 1926
| cat. 32

Fig. 18 | **Palmer Hayden**
Café L'Avenue
watercolor on paper
1932
cat. 23

In sharp contrast to Hayden, painter Laura Wheeler Waring (1887-1948) viewed humanity and her environment in refined, stately terms. Her portraits from the 1920s extend the bravura brushstrokes and haughty poses of John Singer Sargent into New Negro representations. However, intimations of a less self-conscious and more exuberant approach to painting can be seen in Waring's 1928 painting, *Still Life* (fig. 19). Commissioned by the Evans-Tibbs Collection's spiritual mother, opera singer Madame Lillian Evanti, Waring's *Still Life* is a riotous display of colors, textures, and floral patterns from an otherwise conservative artist. The work attests to the occasional overtures by many American painters during the 1920s to the post-impressionist legacies of Cézanne, Matisse, and other European modernists. Waring, like countless American artists before her, made the trek to France in order to study the great masters and to have direct contact with a living, artistic tradition. In *Still Life*, Waring's painterly passions and her affinities for a modicum of modernist principles are fully realized.

Interestingly, Waring's painting is partially visible in the background of a portrait of Madame Lillian Evanti (ca. 1934; fig. 20) by photographer Addison Scurlock (1883-1964). As Washington, D.C.'s counterpart to New York's Van DerZee, Scurlock photographed Madame Evanti and his other black clientele with a keen awareness for their respective styles and notions of self-presentation. In another photograph of Madame Evanti (ca. 1937; fig. 21) by the Alabama-based photographer P.H. Polk (1898-1984), the atmosphere is less theatrical but still very much preoccupied with fashion and elegance. Although the Polk photograph was taken outdoors with an informal ambiance, the stylish suit worn by Madame Evanti and the inclusion in the portrait of a Russian wolfhound recall a Parisian fashion photo study rather than an impromptu snapshot.

This tendency in early twentieth-century photography by African Americans—placing personal style, decorum, and flash over unflattering realism and grit—was not seriously challenged until the advent of the Great Depression and the resulting shift in artists' perspectives toward the common man. The next generation of black photographers, while not ignoring the fashionable and elegant aspects of black life, embraced a broader social agenda in their work than seen in the photographs by Scurlock, Polk, and Van DerZee. Yet one could argue that these photographic images of black America's foremost opera singer and a black fraternal organization were themselves powerful visual statements which refuted the prevailing, black stereotypes and gave black Americans an uplifting and idealized picture of themselves.[2]

Two African-American artists who succeeded in creating a balance between an art of inspirational propaganda and an art of formal and conceptual intrigue during the late 1920s and early 1930s are James Lesesne Wells (b. 1902) and Aaron Douglas (1889-1979). Both were recognized in their youth as promising talents and achieved some notoriety during the Negro Renaissance period for developing new ways of seeing the black experience.

After several years of training at the National Academy of Design and Columbia University Teachers College, James Lesesne Wells emerged in the early 1930s as a major printmaker and painter, especially of religious subjects. His background as the son of a Baptist minister encouraged his exploration of religious art, as did his independent studies into the spiritually charged works of traditional African sculptors and contemporary German expressionist artists. Wells' *Escape*

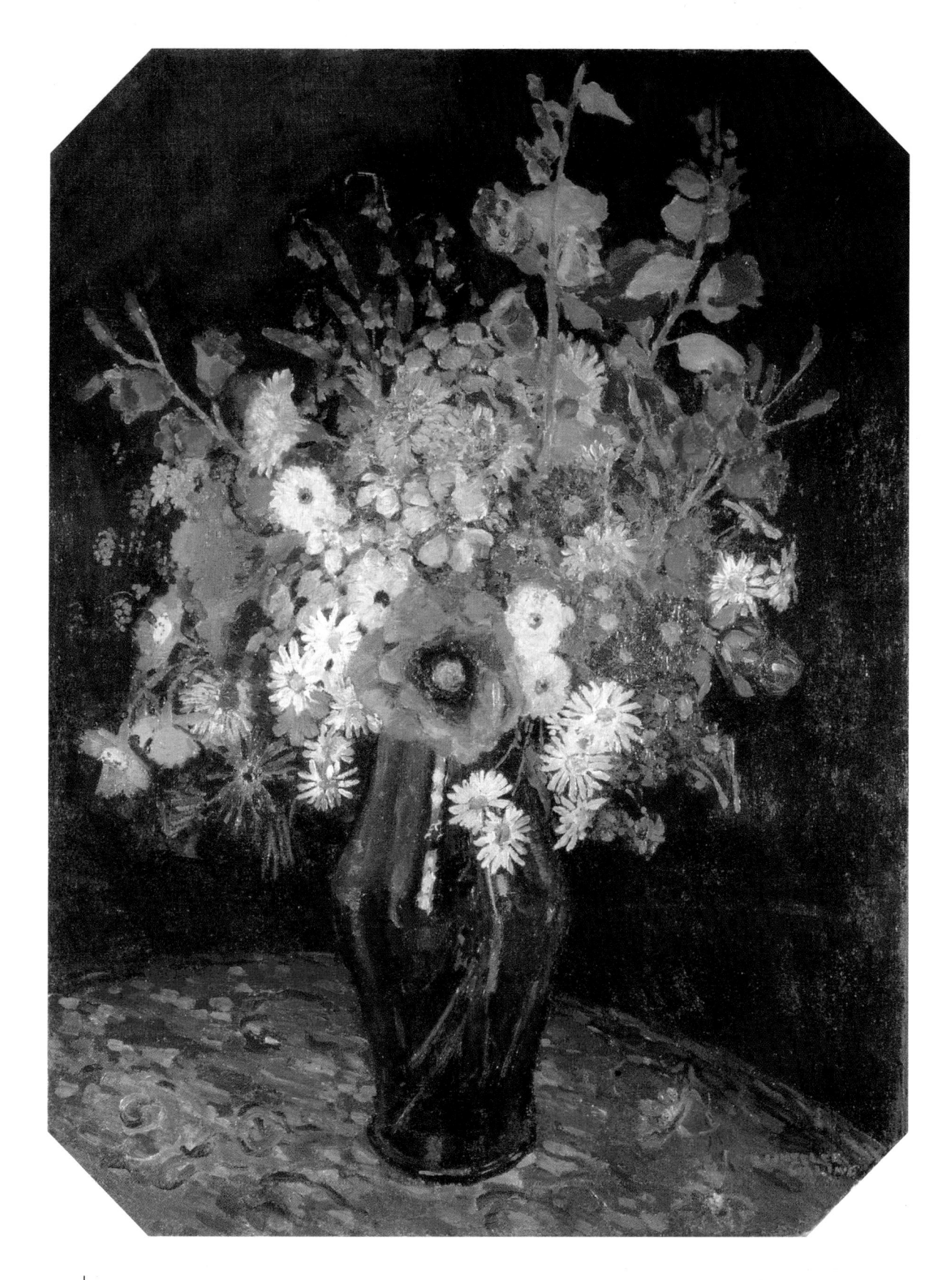

Fig. 19 | **Laura Wheeler Waring**
Still Life
oil on canvas
1928
cat. 33

Fig. 20 | **Addison Scurlock**
Portrait of Madame Evanti (Lillian Tibbs)
photograph
about 1934
cat. 29

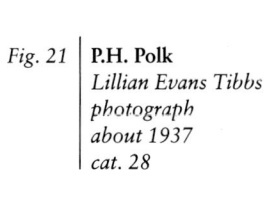

of the Spies from Canaan (ca. 1933; fig. 22), with its high contrast, chiaroscuro treatment of figures in a shallow space, was a bold step for the artist, given the bias toward representational, yet idealized works favored by many critics and audiences of the time. Wells' two-dimensional and graphic interpretation of a biblical moment joins the streamlined designs and allegorical subjects of such fellow graphic artists as Rockwell Kent, Frans Masereel, and Miguel Covarrubias. But unlike the works of Wells' contemporaries, Escape of the Spies from Canaan and other pieces by the artist respond to the spiritual side of black America, and its growing empathy, in the early 1930s, for the new and the modern.

Like Wells, Aaron Douglas first came to the public's attention in the late 1920s as an illustrator of books and magazines. Produced to accompany the writings of Langston Hughes, James Weldon Johnson, Eugene O'Neill, and others, Douglas' drawings ensured his place in American arts and letters as the quintessential artist of the Negro Renaissance. Douglas' large scale murals also brought him to the attention of the average citizen, who was more likely to encounter his work in various schools, libraries, community centers, and exposition halls throughout the United States.

Aspiration (fig. 23), a mural created for the 1936 Texas Centennial Exposition's "Hall of Negro Life," epitomizes the style for which Douglas was best known. Comprised of figural and architectonic silhouettes, Aspiration traces the development of the Negro from slavery (symbolized by the shackled arms in the foreground), through the present (in the middleground, the three people hold various tools of learning), and into the future (suggested by the distant vista of skyscrapers and factories).[3] Douglas' violet and green color scheme, as well as his streamlined approach to form, gives Aspiration a truly moderne look, as does his dramatic overlay of star, circle, and parallel-wave geometries. Yet these overtures to abstraction and the international style are intentionally harnessed, via Douglas' figuration, to more racial and socially motivated ends.

It is in this didactic and culturally conscious realm that artists like Aaron Douglas and James Lesesne Wells stood apart from most of their contemporaries; they chose to visualize the lofty ideals of the New Negro in an expanded, modern language.

In the wake of the Great Depression came an erosion of the idealistic aims of the Negro Renaissance. Economic hardships, coupled with a heightened awareness of the social plight of most black Americans, tempered the upbeat, optimistic mood of the previous decade. Government-sponsored assistance programs (such as the Works Progress Administration) and community-based activism, generated by political and religious groups, responded to black America's bleak state of affairs. In turn, these efforts triggered among black artists and intellectuals perhaps an even greater sense of racial pride and social responsibility than expressed during the Negro Renaissance period. Works such as Aaron Douglas' Aspiration exemplify this decided shift toward an art of social engagement and celebration of Negro culture.

One of the major themes of African-American art at this juncture was the black subject itself. In contrast to works like Barthé's Portrait of Harold Jackman, which promote a more caucasian, racially mixed model as the aesthetic ideal, art works such as Girl in a Red Dress (1934; fig. 24) by Charles Alston (1907-1977) and Negro Worker (1945; fig. 25) by James Lesesne Wells salute African physiognomy and hold it up as a standard of beauty and pride. The reverberations

Fig. 22 **James Lesesne Wells**
Escape of the Spies from Canaan
linoleum cut print
about 1933
cat. 35

Fig. 23 | **Aaron Douglas**
Aspiration
oil on canvas
1936
cat. 21

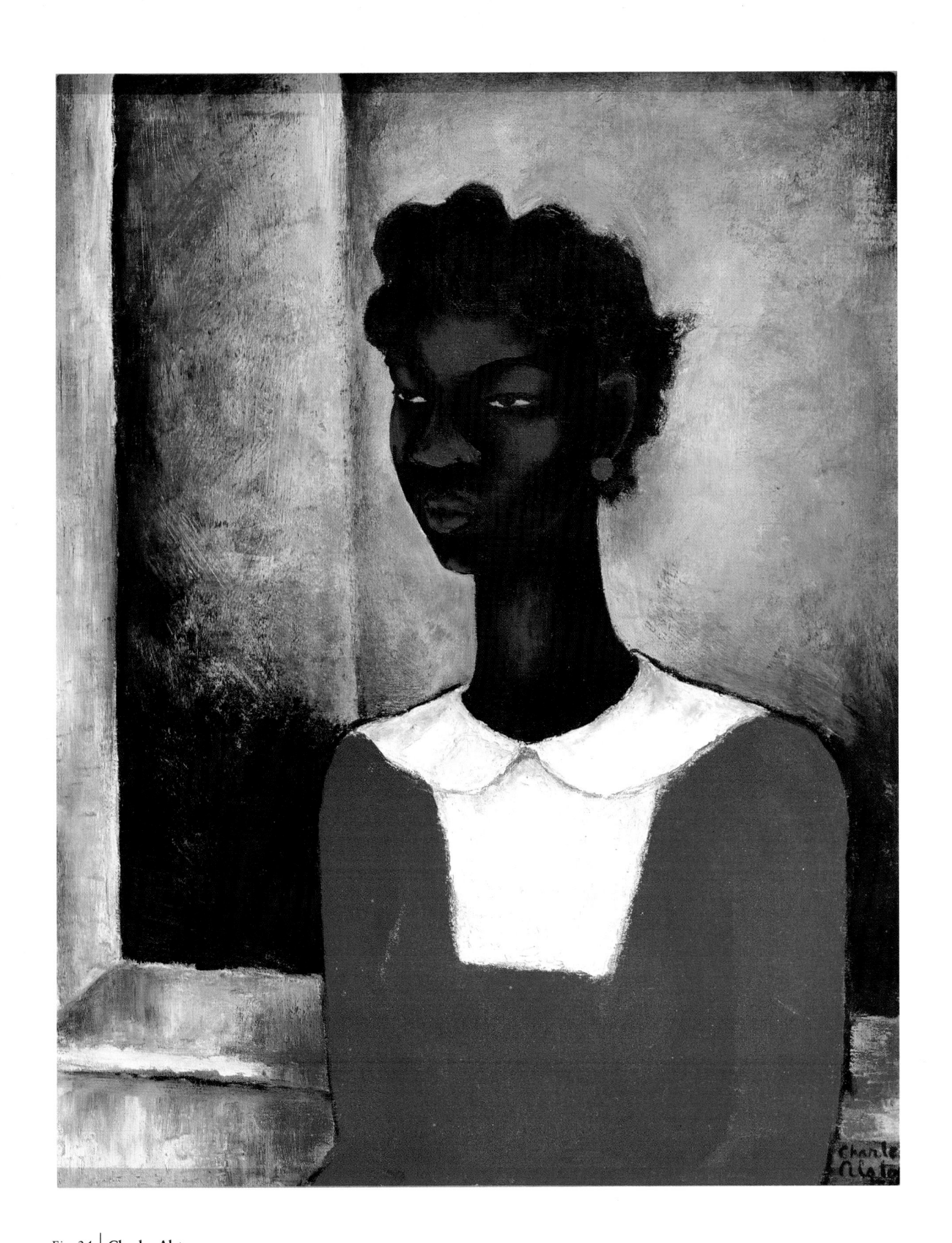

Fig. 24 | **Charles Alston**
Girl in a Red Dress
oil on canvas
1934
cat. 16

Fig. 25 | **James Lesesne Wells**
Negro Worker
lithograph
1945 (about 1938 original)
cat. 34

Fig. 26 | **Lois Mailou Jones**
The Lovers (Somali Friends)
casein on canvas
1950
cat. 26

that Alston's painting has with the popular Langston Hughes poem, "When Sue Wears Red," as well as with the symbolic figures in Aaron Douglas' murals, would have been noted by viewers of the time. Similarly, Wells' *Negro Worker* recalls a plethora of proletarian themes present in countless forms throughout black America in the 1930s and 1940s.

Although painted at the beginning of the 1950s, *The Lovers (Somali Friends)* (fig. 26) by Lois Mailou Jones (b. 1905) represents the continuation of some of the same concerns which preoccupied Alston and Wells in the 1930s. Jones' painting, a beneficiary of the artist's broad experience and exposure to black culture throughout the world, juxtaposes a depiction of two East Africans with flat areas of color and design. Though technically a double-portrait, *The Lovers* is actually an assemblage of faces, design remnants, and color, all paying tribute to an African heritage through a set of established, visual codes.

Two artists in the Evans-Tibbs Collection who were thoroughly conversant in this African-American lexicon of visual codes are Sargent Johnson (1888-1967) and Eldzier Cortor (b. 1916). Johnson, who first came into prominence in the late 1920s for his sculpture in the Art Deco style, maintained his foothold in the art world throughout the 1940s with works both in sculpture and printmaking. *Singing Saints* (fig. 27), a lithograph from 1940, incorporates a musical subtext into a semi-abstract rendering of two figures. Like many of Johnson's other works, *Singing Saints* makes culture (i.e., black religion and black music) its thematic core and, thus, joins a larger corpus of art works produced around 1940, that are also concerned with black Americana.

Eldzier Cortor's *Man with a Sickle* (ca. 1945; fig. 28) is another work of art whose subject is based on black experiences and/or black sentiments. In Cortor's drawing, the disembodied head and hand of a black man flank the clear and carefully delineated rendering of a sickle. Ostensibly a figure study, the work seems symbolic as well, with the sickle and man's angular head evoking the hammer-and-sickle motif of the Communist party. While nothing in Cortor's biography indicates that he was affiliated with or even interested in communism, his artistic haunts during this time— Chicago's South and near North sides—were the stomping grounds for countless artists and activists with leftist sympathies. As with James Lesesne Wells' *Negro Worker,* Cortor's *Man with a Sickle* illuminates a provocative juncture in the 1940s between black America, issues of labor, and a Marxist perspective.

Like Cortor, painters Charles Sebree (1914-1985) and Margaret Burroughs (b. 1917) were participants in the cultural activities which emanated from Chicago's South side in the late 1930s and early 1940s.[4] Despite their distance from New York's art world, Sebree and Burroughs managed to take advantage of Chicago's many resources in order to develop their own respective modes of artistic expression. *Boy in a Blue Jacket* (1938; fig. 29) illustrates both Sebree's thorough appreciation for the post-impressionist masterworks at the Art Institute of Chicago and his very own affinities for expressionism in art. Similarly, Burroughs' *Still Life* (ca. 1943; fig. 30), with its overtures to cubist form and expressionist handling of paint, affirms the influential role of the Art Institute's instructor Kathleen Blackshear in fostering among students an understanding of various modern art idioms. Burroughs, Sebree, and Cortor all inherited a visual and humanitarian legacy in Chicago that, as their work illustrates, produced a myriad of artistic statements.

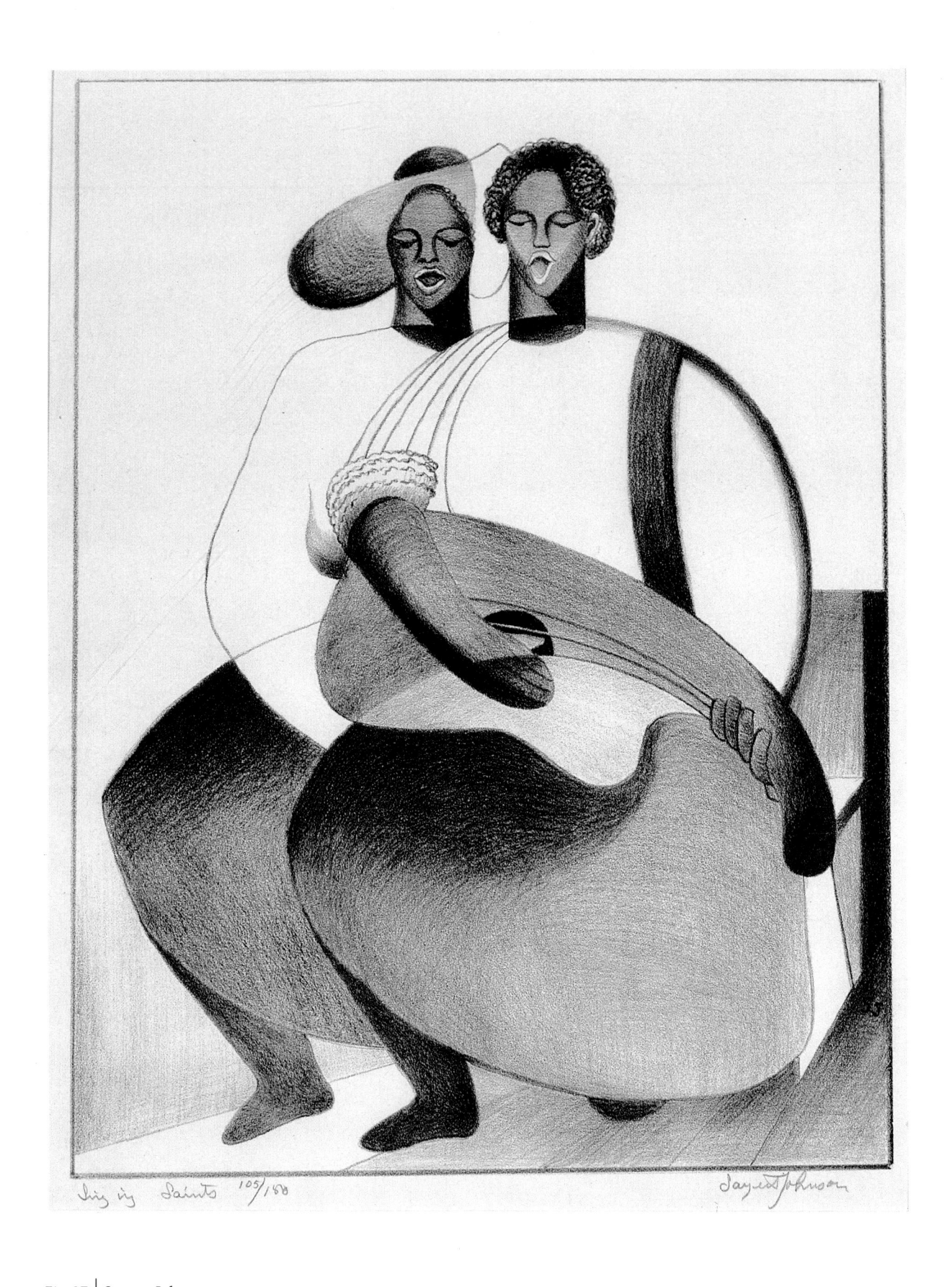

Fig. 27 | **Sargent Johnson**
Singing Saints
lithograph
1940
cat. 25

Fig. 28 | **Eldzier Cortor**
Man with a Sickle
colored pencil, watercolor, pen and ink on paper
about 1945
cat. 19

Fig. 29 | **Charles Sebree**
Boy in a Blue Jacket
oil on canvas
1938
cat. 30

As a result of the Works Progress Administration's Federal Arts Project, black artists (along with their white counterparts) received direct government support for their creative output. This encouragement on the part of the federal government, and its special role in providing patronage for black artists, helped set the stage for the study and appreciation of a faction of black artists who were removed from the already closed world of art museums and commercial galleries. This group of artistic "outsiders"—black, self-taught, and usually residents of small rural communities in the South—were considered *intuitive* talents and the closest thing to authentic American artists beyond colonial limners or American Indian masters. No doubt, part of their popularity stemmed from a temporary fascination among collectors in the 1930s and 1940s for works of art which appeared to be free of all modern influences. Frequently described as either "primitives" or "folk artists," these black painters, sculptors, and carvers achieved a recognition which often surpassed that of their more sophisticated black brethren.

Two of these black "outsiders"—Bill Traylor (1854-1947) and Clementine Hunter (1885-1988)—are represented in the Evans-Tibbs Collection with works that, because of their unpretentious formats and charming scenarios, triggered much critical notice at the time of their unveiling. Traylor's two untitled works (1938-1943; figs. 31 and 32) reveal his uncanny ability to create provocative images from simple drawing techniques. The drawing of a cat alongside an anthropomorphic figure is especially illustrative of Traylor's vivid imagination. In this and other works by Traylor, animals, the farm environment, and the artist's subconscious conspire to produce the most fantastic apparitions—images that, under-

standably, would have appealed to both modernists and traditionalists. Clementine Hunter's *The Pole Watchers* (ca. 1948; fig. 33), in spite of its naive treatment of the subject, is an elegant composition. The surreal shapes of the flanking trees and the spots of brilliant color that represent the three "pole watchers" indicate how certain elements of modern art are also part of the visual vocabulary of artists who, like Hunter, were isolated from the manifestos, movements, and "isms" of many twentieth-century painters and sculptors.

This separation between folk artists and modern culture, however, did not prevent modern artists from experiencing aspects of a rural, pre-industrial folk life. In fact, there was the sentiment during the 1930s and 1940s that the American landscape and the common folk were appropriate subjects for an *authentic* American art. Hale Woodruff (1900-1980), a black modernist who earlier had perfected his painting technique both among the post-impressionists in Paris and the Mexican muralists, embraced in 1936 an art almost exclusively comprised of black share-croppers, vernacular architecture, and desolate Georgia landscapes (fig. 34). Rex Gorleigh (1902-1987), whose independent art studies took him from New York to Paris, and later, to Helsinki, Finland, eventually settled in Greensboro, North Carolina, where his imagination connected with the rhythms of small-town life to produce folkloric works such as *Planting* (1943; fig. 35). Both Gorleigh and Woodruff perceived their respective return to the black American ancestral homeland as proper and fitting for the times.[5] Ironically, it would be Woodruff who, some ten years later, turned away from politically focused Negro art and exhibitions, to a "fully integrated" context for his paintings.[6]

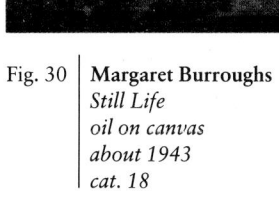

Fig. 30 | **Margaret Burroughs**
Still Life
oil on canvas
about 1943
cat. 18

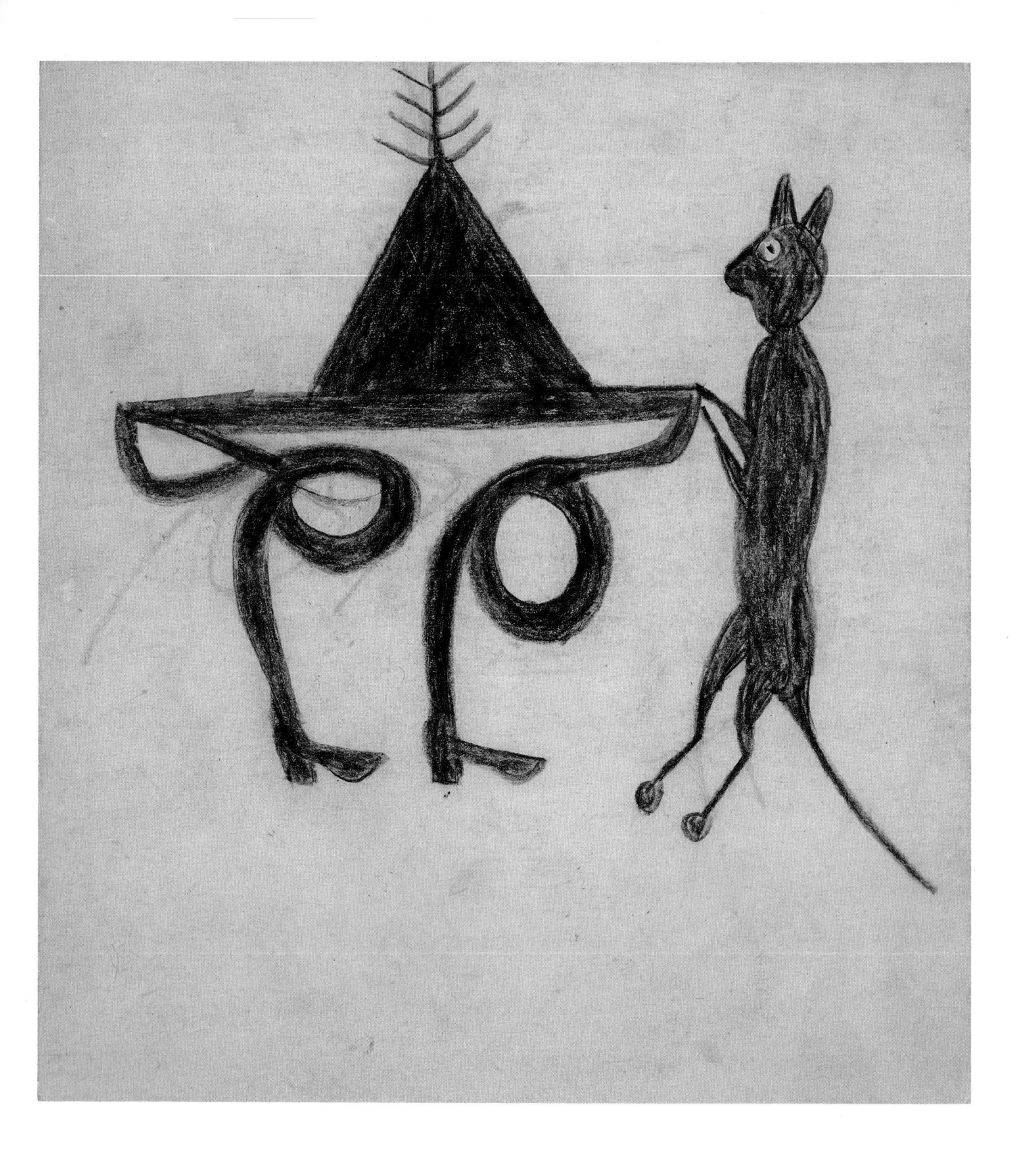

Fig. 31 | **Bill Traylor**
untitled (Anthropomorphic Figure and Cat)
pencil on cardboard
about 1938-1943
cat. 31

Fig. 32 | **Bill Traylor**
untitled (Woman with Purse)
tempera on cardboard
about 1938-1943
cat. 36

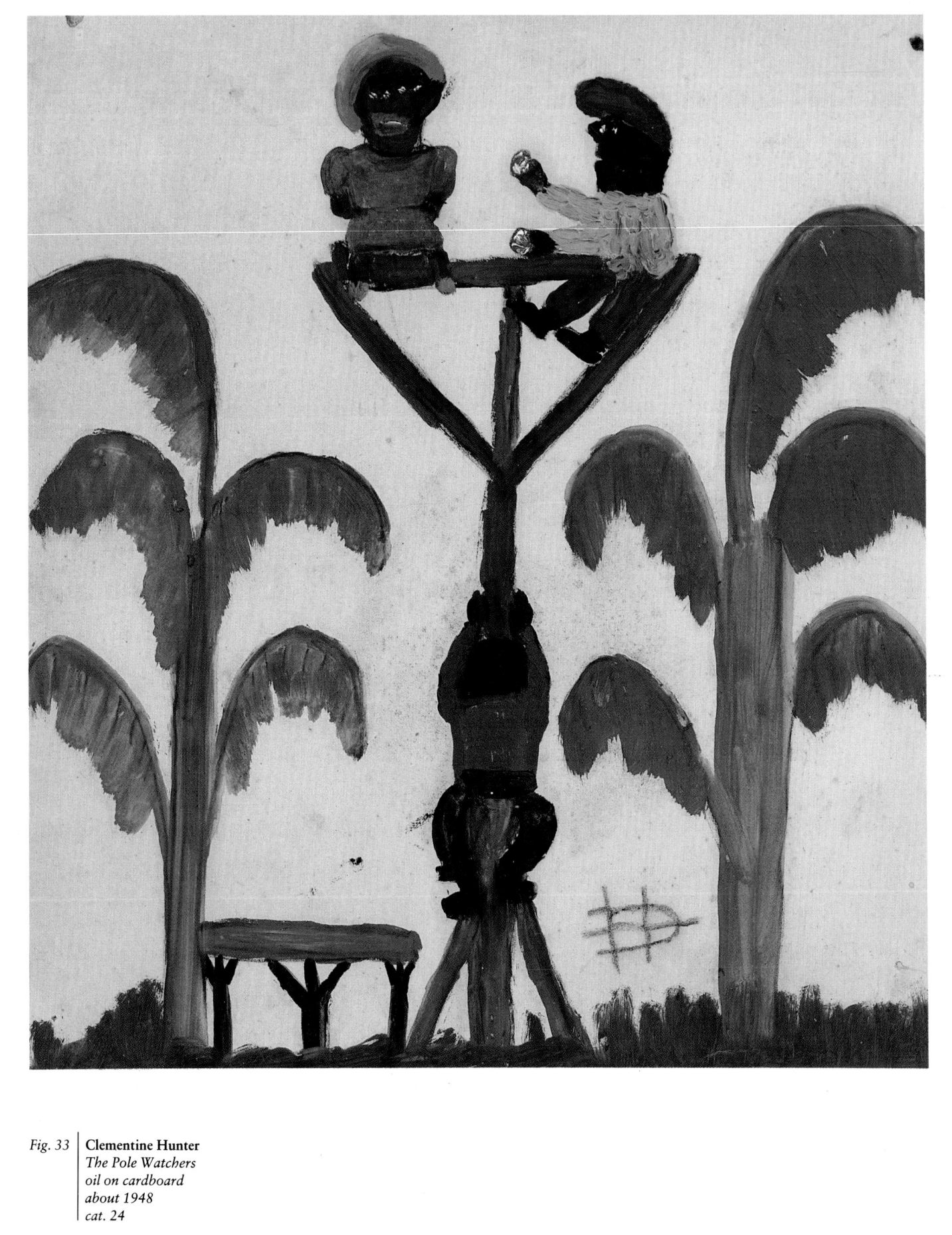

Fig. 33 | **Clementine Hunter**
The Pole Watchers
oil on cardboard
about 1948
cat. 24

Fig. 34 | **Hale A. Woodruff**
Landscape
oil on canvas
about 1936
cat. 37

After subduing the various "enemies of freedom" during World War II, black Americans adopted the attitude that, once they joined America's cultural mainstream, a place at America's proverbial "table" would be within easy reach. Even when this line of thinking was not conscious, there was the sense (at least among some black artists) that racially oriented, isolationist points-of-view were no longer necessary or desirable.

The Family (1948; fig. 36) by Romare Bearden (1914-1988) illustrates how one black artist embraced a more ethnically neutral perspective in this post-war period. Made up of cubist fractures and the color intense palette of the abstract expressionists, *The Family* presents three figures in a multi-cultural fashion. Although this mixture is clearly derived from Bearden's study of African sculptural form, the particular format employed here situates *The Family* squarely within the mythic and modernist realm of late 1940s, New York-style painting.

Similarly at home in the New York school, but extending beyond its confines via spiritual and philosophical elements, is an untitled work of 1946 (fig. 37) by Beauford Delaney (1901-1979). A gentle individualist, Delaney rarely followed trends of any kind, as evidenced in the strange gathering of painted parts in this work. Yet it is precisely Delaney's odd juxtaposition here of impasto painting, a heraldic composition, and the enigmatic which simultaneously separates and joins this composition to black America.

Despite this inclination among many black artists to distance themselves from ethnic concerns, one of the most celebrated black artists of the period—Jacob Lawrence (b. 1917)—continued to think in terms of black imagery and African-American themes. Lawrence's *Graduation* (fig. 38), a gouache on paper from 1948, captures the expressive dynamism which is often a part of black communal life. Painted originally as one of several illustrations appearing in Langston Hughes' book of poetry, *One-Way Ticket*, Lawrence's *Graduation* is a successful merger of narration and design, skillfully rendered by the artist in jagged areas of black and white. Oddly enough, in this period of increased attention toward abstract expressionism and mainstream culture, Jacob Lawrence maintained an aesthetic allegiance to black America which, in turn, was supported by the marketplace. (For other black artists, however, acceptance in the commercial art world was the exception rather than the rule.)[7] Lawrence, along with Bearden, Delaney, and other black artists, faced the decade of the 1950s with guarded optimism, though the prospect of an unpredictable and changing art scene loomed on the horizon.

Wedged between the flexing of artistic muscles in the nineteenth and early twentieth centuries, and the flowering of a new cultural consciousness and independence starting in the middle of the twentieth century, African-American art between 1920 and 1950 played a crucial role in giving visual form to black ideals.[8] As selected works of art from the Evans-Tibbs Collection illustrate, this thirty-year period presented a myriad of attitudes from black Americans. From Van DerZee's *Alpha Phi Alpha Basketball Team* to Bearden's *The Family*, one can comprehend the breadth of self-imagery and cultural groundedness that black Americans experienced through the Negro Renaissance, Great Depression, and World War II years. Depending on the specific historical moment when the artist conceived of an image, the culture and the art, more often than not, reflected the pulse and the mood of the people.

Fig. 35 | **Rex Gorleigh**
| *Planting*
| *watercolor and tempera on paper*
| *1943*
| *cat. 22*

Fig. 36 | **Romare Bearden**
The Family
watercolor and gouache on paper
1948
cat. 17

Fig. 37 | **Beauford Delaney**
untitled
oil on canvas
1946
cat. 20

Fig. 38 | **Jacob Lawrence**
Graduation
gouache on paper
1948
cat. 27

NOTES

1. James A. Porter describes the events which led up to this artistic flowering of African-American art in his book, *Modern Negro Art* (New York: Dryden Press, 1943; repr. New York: Arno Press, 1969), 93-108. For the essence of Alain Locke's clarion call to Negro artists, see his "The Legacy of Ancestral Arts," in *The New Negro*, Alain Locke, ed. (New York: Albert and Charles Boni, 1925; repr. New York: Atheneum Press, 1970), 253-67.

2. For a closer look at these and other black photographers, as well as for a discussion of their underlying aesthetic tenets, see Valencia Hollins Coar, ed., *A Century of Black Photographers* (Providence, RI: Rhode Island School of Design Museum of Art, 1983) and Deborah Willis-Thomas, *Black Photographers 1840-1940: A Bio-bibliography* (New York: Garland Publishing, Inc., 1985).

3. *Aspiration* and three other Aaron Douglas murals that were on display in the Hall of Negro Life are described at some length in Jesse O. Thomas, *Negro Participation in the Texas Centennial Exposition* (Boston: The Christopher Publishing House, 1938), 26-7. Although not in the purview of this essay, the Evans-Tibbs Collection owns (in addition to *Aspiration*) another one of these Texas Centennial murals. This second Douglas mural depicts shackled slaves lined up in a coastal forest setting, with a slave ship on the distant horizon.

4. Sebree, Burroughs, and other black Chicago artists are mentioned as key players in Chicago's cultural activities of the 1930s in Robert Bone's essay, "Richard Wright and the Chicago Renaissance," in *Callalloo/ Richard Wright: A Special Issue* 9 (Summer 1986), 446-8.

5. "We are interested," stated Hale Woodruff about himself and his students at Atlanta University, "in expressing the South as a field, as a territory, its peculiar run-down landscape, its social and economic problems, the Negro people...." Quoted in "Black Beaux Art," *Time*, 21 (September 1942), 74. Writing figuratively, the author of this article referred to Woodruff and his students as "The Outhouse School."

6. During negotiations with the International Business Machine (IBM) Corporation in 1947 concerning the purchase of works by black artists, Hale Woodruff was explicit in his belief that no distinctions should be made between the black and white artists in the corporate collection. "In light of the Negro artist's present achievements in the general framework of American art today," wrote Woodruff to one of the participating black artists in the IBM venture, "there does not exist the necessity to continue all Negro exhibitions which tend to isolate him and segregate him from other American artists." From a letter to Charles Alston, February 18, 1947; Charles Alston Papers, Archives of American Art, Smithsonian Institution, Washington, DC.

7. Lawrence's success and celebrity status in the art world can be deduced from not only his consistent exhibition record during the late 1940s and early 1950s, but also in the extensive press coverage that he and his work received. Most notable at this time was his stylish photo portrait (taken by Irving Penn) in an issue of *Vogue*. For a more in depth look at Lawrence, see Ellen Harkin Wheat, *Jacob Lawrence, American Painter* (Seattle: Seattle Art Museum, 1986).

8. In addition to references mentioned previously, parts of this essay were culled from an unpublished paper of mine, commissioned in 1986 by the National Research Council's Committee on the Status of Black Americans. This lengthier work, "The Visual Arts and Afro-America, 1940-1980," examines major trends during a forty-year period in African-American cultural history and appends these to significant events in the art world.

The Search for Identity
1950-1987

Sharon F. Patton

For African-American artists, the Cold War era and the three decades that followed were a time for the further exploration and refinement of artistic philosophy and skills, for the development of an African-American aesthetic, for the attainment of critical recognition, and for survival as artists.

Earlier in the twentieth century, two major personalities, philosopher Alain Locke and painter and art historian James Porter, had set the agenda for contemporary African-American art. While Porter encouraged a generation of black artists to erase the distinctions of race in pursuit of personal expression, Locke was concerned with the deliberate search for and retrieval of elements of black culture that reflected their African origins, and with incorporating these elements into an African-American aesthetic. It was a controversy that was to resurface, with new passion, in the 1960s and 1970s.[1]

The legacy of the 1920s and 1930s—of Alain Locke and the New Negro Movement, of the Harlem

Detail of *Third Avenue El*,
Walter H. Williams,
gouache on paper, 1955
(fig. 39).

Renaissance, of the Works Progress Administration (WPA)—continued into the 1950s, lingering on in the content and technique of several of the "older" generation of artists. The mural tradition of the social realists, both American and Mexican, had left an indelible mark on black artists who were now reaching mid-career. During the Depression years, Mexican Diego Rivera had painted murals in the United States, where they received wide exposure; and although the muralists Jose Clemente Orozco and David Siqueiros executed works primarily in Mexico, by the 1950s many African-American painters had seen them first-hand.

Some artists, however, rebelled against the perceived hegemony of the social realist style by escaping to Western Europe, to what they saw as a more open climate for expression. These artists—Ed Clark, Walter H. Williams, and Robert Thompson, among others—became temporary or permanent expatriates. For those who remained, the assertion of a black identity usually meant the portrayal of black people, although as the decade wore on not necessarily in a strict social realist vein.

In retrospect, American figurative art of the 1950s speaks primarily of pessimism and individual alienation. From about 1916 to 1960, thousands of African Americans, spurred by black newspapers such as the *Chicago Defender,* relocated from the rural South to Chicago, Detroit, Cleveland, St. Louis, Philadelphia, and Pittsburgh—industrial cities whose economic opportunities promised prosperity and the end of racial oppression. The new immigrants, arriving north in a great wave, did not find the gold-paved streets they had imagined, however. Instead they discovered the squalor of urban existence and an omnipresent segregation. Several black artists took this

new environment as their subject matter, conveying the profound disillusionment and the unfulfilled promises that inhabited it.

Walter H. Williams (b. 1930) encapsulated the context and mood of this milieu in *Third Avenue El* (1955; fig. 39). This and similar works by Williams compare to those of Philip Evergood—or of Ben Shahn and Gregoria Prestipino, under whom Williams studied at the Brooklyn Museum School in the early 1950s. *Third Avenue El* refers to the harshness and psychological isolation of Harlem, where Williams spent his childhood.

Like many black artists, including Sam Middleton, Cliff Joseph, and Herbert Gentry, Williams eventually found the encouragement he sought outside his native country. In 1955, he traveled to Mexico as a John Hay Whitney Fellow; ultimately, he left these shores for good to settle in Copenhagen. Only as exiles did many black artists find the idyllic surroundings they were searching for—in Williams' case, flowers, butterflies, and meadows. This new environment eventually found its way into Williams' later pastoral works, although the human figures he painted continued to be black.

In *Cityscape* (1952; fig. 40), Richard W. Dempsey (1919-1987) translates the beauty and barrenness of the northern city into a somber monochromatic grid. By the 1960s, however, Dempsey had relinquished the impersonal urban canyons for landscapes and representation, and for techniques such as the abstract expressionist "drip" method evidenced in *North Carolina* (1965; fig. 41).

After Fiesta, Remorse, Siesta (1959-1960; fig. 42) by Archibald Motley, Jr. (1891-1980) is stylistically similar to his earlier works of the 1920s and 1930s. But here, the usual boisterous

Fig. 39 **Walter H. Williams**
Third Avenue El
gouache on paper
1955
cat. 59

Fig. 40 | **Richard W. Dempsey**
| *Cityscape*
| *oil on board*
| *1955*
| *cat. 43*

Fig. 41 | **Richard W. Dempsey**
North Carolina
watercolor
1965
cat. 60

and raucous mood of jazzy nights, typical of his earlier works, is exchanged for one of melancholy. Motley's characteristic jewel-toned colors and curving, softly glowing figures—delineated against a darker background—create an isolated, moody atmosphere.

Hughie Lee-Smith (b. 1914) excels in using the city as a metaphor for the isolation and apathy of the ghetto. Much of his work portrays a black figure set against the barrenness of the inner city. In *Reflection* (1957; fig. 43), a contemplative man stands on a desolate beach, enveloped by cool, luminous skies. The spatial vastness, broad horizon, and refined palette are akin to the metaphysical reverie of William Stuempfy or Giorgio de Chirico, both of whom Lee-Smith admits to have influenced his own works.

In the 1950s, although artists saw the urban ghetto as a place of pessimism and isolation, their presentation was often detached—"objective," in the manner of reportage or documentary. In the 1960s, the ghetto continued to be a subject, but now black artists—some of them the second or third generation African Americans living in the northern cities—were becoming less distanced from the subject, as in *Gemini* (1965; fig. 44) by Lev T. Mills (b. 1940). The energies of the civil rights movement, in part, had ignited a new subjectivity and passion among black artists.

Yet, as in the 1920s and 1930s, these artists, and their works, were often taken less seriously by critics because they were out of step with current avant-garde styles—in this case, abstract expressionism, minimalism, and conceptualism. Social realism, or "protest" art, was considered a pejorative term by mainstream artists and critics. But many African-American artists, including Charles White (1918-1979) and Elizabeth Catlett (b. 1915)

clung to an interest in realism and the figure. The image was, for them, a symbol of racial and cultural pride—the same notion that Alain Locke had championed several decades earlier.

Locke's *The New Negro,* illustrated by Winold Reiss, had been a formative influence on White. An exemplary draftsman, White's incisive line and commanding figurative style reflected his admiration for Siqueiros and Rivera, and his experience as a muralist during his employment in the Federal Arts Project of the WPA.

In 1946, White visited the Taller de Grafica Popular in Mexico with Elizabeth Catlett (his wife at the time). This visit, combined with his experience as an illustrator in the 1940s, culminated in his portrayal of blacks with a poignancy and dignity rarely seen in American art. *Sounds of Silence* (1978; fig. 45) is typical of his work in the mid-1970s; a single figure, without background and the stylized distortion of his earlier works, commands the viewer's attention. It has what Peter Clothier termed "lyrical isolation."

Elizabeth Catlett shared White's interest in the human figure. She employed the figure, always black, to convey a sense of pride and dignity. Known primarily as a sculptor, Catlett refined her skills as a printmaker when she arrived at Taller de Grafica. She eventually became a member of Taller and chair of the art department at Mexico's National University. *Sharecropper* (1970; fig. 46) has the sculptural clarity of form and planar articulation that is seen in her works dating from the 1950s.

Catlett too was influenced by the style and purpose of the Mexican muralists. "Art should come from the people and be for the people. Art for now must develop from a necessity within my people. It must answer a question, or wake some-

Fig. 42 | **Archibald Motley Jr.**
| *After Fiesta, Remorse, Siesta*
| *oil on canvas*
| *1959-60*
| *cat. 41*

Fig. 43 | **Hughie Lee-Smith**
Reflection
oil on canvas
1957
cat. 54

80 AFRICAN-AMERICAN ARTISTS

Fig. 44 | **Lev T. Mills**
Gemini I
etching
1969
cat. 42

Fig. 45 | **Charles White**
Sounds of Silence
lithograph
1978
cat. 64

Fig. 46 | **Elizabeth Catlett**
Sharecropper
woodcut
1970
cat. 65

body up, or give a shove in the right direction—our liberation."[2]

Benny Andrews, a painter very familiar with the struggle to gain recognition, once wrote that "black artists fought against an ingrained system that refused to allow them the one thing that practically everyone gives as the premise for individual artistic endeavors: the need to express oneself."[3] While some black artists of the 1950s opted for social realism, or left the country to find their own way, others were swept up in the new movements that came to dominate the American avant-garde of the 1950s.

The decade was a time of experimentation, as many artists were attempting to discover an uniquely American style. The hotbed of this experimentation was New York City; the style was abstract expressionism. Among its major exponents were Adolph Gottlieb, Mark Rothko, Robert Motherwell, Jackson Pollock, Theodore Stamos, William Baziotes, Romare Bearden, Norman Lewis, and another artist named Hale Woodruff (1900-1980).

While a professor at New York University, Woodruff befriended Rothko, Motherwell, Baziotes, and later Barnett Newman. Modernism was fashionable and promoted in the galleries and studios. It was also finding its way into the temperament of American society. Many of the proponents of modernism were Europeans, who had encouraged the "new abstraction" when they migrated to New York during and after the war.[4] Process, for these artists, was as important as the image.

By the 1950s, Woodruff had already abandoned his earlier representational style. But the formalizing and intensely introspective view of modernism did not satisfy the aesthetic requirements he and many other African-American artists put upon their work. They wanted to create works whose imagery was abstract, yet still understood by their African-American public. The paintings Woodruff executed immediately after his arrival in New York in the late 1940s became less structured. And with his landscapes—considered his most unrestrained group of paintings—he eventually adopted the abstract expressionist aesthetic, as in *Caprice* (1962; fig. 47). In this work, broad brushstrokes of earth-toned colors sweep and converge toward the center of the canvas.

African-American artists in the 1950s did not merely seek to identify with 1950s modernism, or with what Cedric Dover termed "mid-twentieth century internationalism." They viewed themselves as African-American *and* American artists. They sought to maintain their ties to black people.

The events of the civil rights movement were an awakening for black artists. In 1963, Romare Bearden, Norman Lewis, and Woodruff met in New York in order to "discuss their position in American society and to explore other common problems." They called their group Spiral, which Woodruff suggested because it is an "Archimedean symbol, as an emblem of progression, onward and upward forever."[5] Spiral was the opportunity to speak of a cultural self.

Spiral eventually expanded to fifteen members, and included Richard Mayhew (b. 1934). Once a week, the group got together to shout, to embrace, to cuss, and to talk.[6] For Mayhew, it was a means to confirm what he had already done, a personal acknowledgment of his African-American past without a breach of his aesthetics.

Fig. 47 | **Hale A. Woodruff**
Caprice
oil on canvas
1962
cat. 57

Fig. 48 | **Richard Mayhew**
| *Vibrato*
| *oil on canvas*
| *1974*
| *cat. 40*

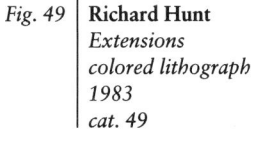

Fig. 49 | **Richard Hunt**
Extensions
colored lithograph
1983
cat. 49

Mayhew began to paint seriously at a time when abstraction dominated American painting. Mayhew's reputation as a colorist whose compositions suggest music as a point of departure is clearly evident in *Vibrato* (1974; fig. 48). Nature is equated with color, which is in turn equated with sound. In his works, subtly modulated colors create an impressionistic landscape, one that is thoroughly personal. Mayhew's experience as a jazz singer and his love for jazz have greatly influenced his works.

The exploration of abstract expressionism—for many black artists, into the 1980s—has been predicated on the formal elements of nature. *Extensions* (1983; fig. 49) by Richard Hunt (b. 1935) translates the organic forms of the sculptor's steel sculptures into rhythmic "extensions." *Nature Study No. 20* (1980; fig. 50), by Mary Reed Daniel (b. 1946), interprets the landscape as flat, abstract bands of brilliant color. The search for the essence of nature and of spirituality has been an ongoing theme in black art, one that would find expression in the fertile soil of a movement that took root in the nation's capital in the late 1950s and 1960s.

The Washington Color School refers, in general, to what is known as color-field painting. During the 1950s, the Washington Workshop Center for the Arts, founded by Leon Berkowitz, offered classes for black and white students. The workshop encouraged individuals on the verge of becoming major artists to teach there; among its instructors were Ralph de Burgos, Leo Steppart, Howard Mehring, and Tom Downing. Clement Greenberg, Willem de Kooning, and Morris Louis lectured there as well.

Two students of the Washington Workshop Center were Delilah Pierce (b. 1904) and Alma Thomas (1894-1978). After retiring from teaching at the age of sixty, Alma Thomas, the first student and graduate of Howard University's art department, embarked upon a career which made her the leading female abstract painter of the late-twentieth century. Her inimical prismatic color-field paintings, first produced in the early 1960s, led her to national prominence in the 1970s. Rather than directly depict nature, Thomas used the application of color as metaphor for the natural order of the environment—the way color was laid down reflected the form of the landscape.

Thomas' *Leaves Outside a Window in Rain* (1966; fig. 51) belongs to a series of untitled watercolors produced in the 1960s. These works, typical studies for her large oil paintings, focus on seasonal changes in the landscape, especially on trees and leaves. Thomas was interested in the play of light and dark, and leaves often became mosaics of delicate translucent color. Of paramount importance to Thomas was color, for through color Thomas sought to concentrate on beauty and happiness. "Man's highest inspiration comes from nature. Color is life, for a world without color appears to us dead. Colors are primordial ideas, the children, light."[7]

Delilah Pierce shared Thomas' interest in the effects of light and atmosphere in the country woodlands and city landscapes. *Nebulae* (1982; fig. 52) uses color as a spatial and formal element. Whereas Thomas' interest was in plants and flowers, Pierce's interest is the sea and sky.

Having studied under Morris Louis at Howard University and under Kenneth Noland at Catholic University, David Driskell (b. 1931) also showed an increasing interest in color as a structural element of the landscape. In *Movement, The Mountain* (1980; fig. 53) there is the skillful employment of rich opulent color that translates form and content. The concern with social commentary, typical of Driskell's earlier works, began to disappear as he relentlessly pursued abstraction

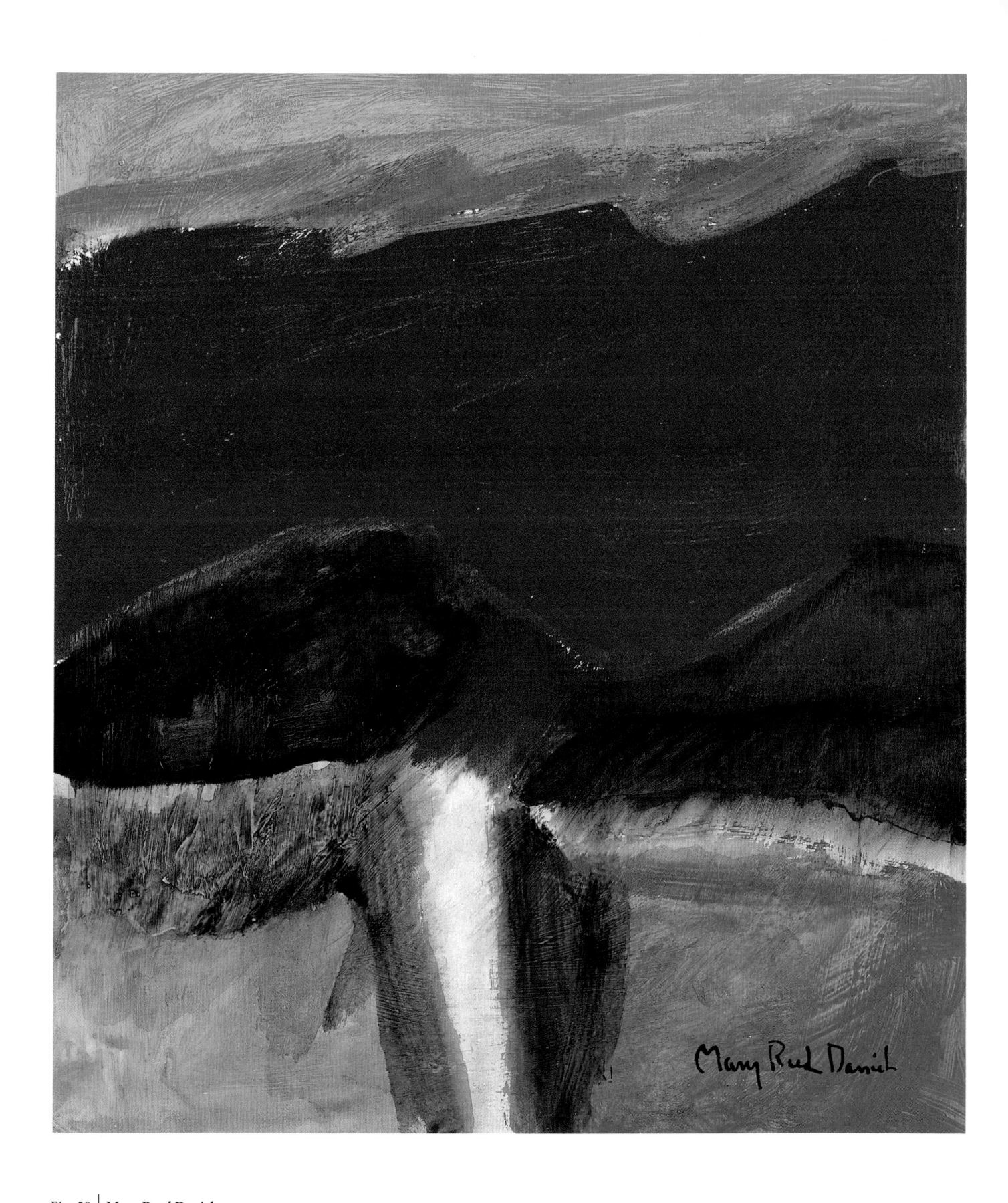

Fig. 50 **Mary Reed Daniel**
Nature Study No. 20
acrylic on paper
1980
cat. 46

Fig. 51 | **Alma Thomas**
| *Leaves Outside a Window in Rain*
| *watercolor*
| *1966*
| *cat. 55*

Fig. 52 | **Delilah Pierce**
Nebulae
watercolor
1982
cat. 52

Fig. 53 | **David C. Driskell**
Movement, The Mountain
egg tempera on canvas
1980
cat. 44

and investigated the lyricism of color. This change was encouraged in the 1960s when, teaching at Howard University, Driskell realized that the social realist style of the 1950s was too muted for the more radical challenges of the 1960s. Echoing what Benny Andrews had said two decades earlier, Driskell said:

> I'm delighted with every artist working doing whatever he or she wishes to do as long as they do not insist that I must give up my own freedom of expression to join them eclectically. I have as much feeling for the conceptual artist as I do for what I'm doing. However, I feel compelled to pursue form in my own way. Perhaps I shall feel otherwise someday. As long as we remain human, art will be a necessary form of expression. When we are less human, our art stinks.[8]

But it was Sam Gilliam (b. 1933) who became the first important black artist to totally focus his ideas on form rather than content—an idea completely consonant with the work of the Color School artists. Within a year after his arrival in Washington from Louisville in the late 1950s, Gilliam had changed from a figurative style resembling Richard Diebenkorn's early works to abstraction, apparently a result of his study of Hans Hofmann and the mainstream styles of the most vanguard artists. And he credits much of this change to Tom Downing for making him "look at modernist painting" for the first time.

Gilliam's identity as a black man was merely incidental to his skill as an artist of the movement. "The key to Gilliam's early success," said Keith Morrison, "was based on his application of structuralist methodology to the possibilities of color stains and cloth supports. The brilliance of Gilliam's work lay in the premise of the inevitable extension of pigment."[9] Gilliam quickly moved to the vanguard of contemporary colorist painters, catapulted to fame by Walter

Hopp's "Gilliam/Krebs/McGowin" exhibition at The Corcoran Gallery of Art in 1969.

The innovative process of paint spattered, stained, and draped canvasses begun in the mid-1960s occurred after Gilliam had experimented with the color and spatial effects created by rolling and folding small watercolors a few years earlier, as in a later work, *Abstraction* (1969; fig. 54). Metallic (aluminum-treated paper), creased, and color-stained surfaces show the spontaneous improvisational technique reminiscent of the action paintings of Jackson Pollock, but which evidences the primacy of color.

Gilliam belongs to the same generation of younger artists in Washington, D.C., who also have developed out of the teachings of the Color School, and yet must be kept somewhat separate from that tradition. *Mamie Harrington* (1986; fig. 55) by Sylvia Snowden (b. 1942), for instance, displays an acute interest in the interactions of color and technique. Yet, Snowden's thickly impastoed and murky images cannot be directly linked to the Washington Color School.

Ironically, star status never came to Thomas or Gilliam. Their stature existed primarily within the confines of the District of Columbia—unlike their Washington colleagues Morris Louis, Kenneth Noland, and Clement Greenberg, who achieved international recognition.

Around the same time that Sam Gilliam arrived in Washington, another black artist from Louisville had landed in New York. Robert Thompson (1936-1966) was also at first a figurative painter in style of Bischoff or Diebenkorn. But by 1960, his silhouetted figures began to exist in brilliantly colored landscapes.

Thompson's figurative compositions are appropriations from other artists, such as Gauguin, Matisse, Goya, and Italian Renaissance painters Massacio, Titian, and Piero della Francesca. In these, art history is recycled and reinter-

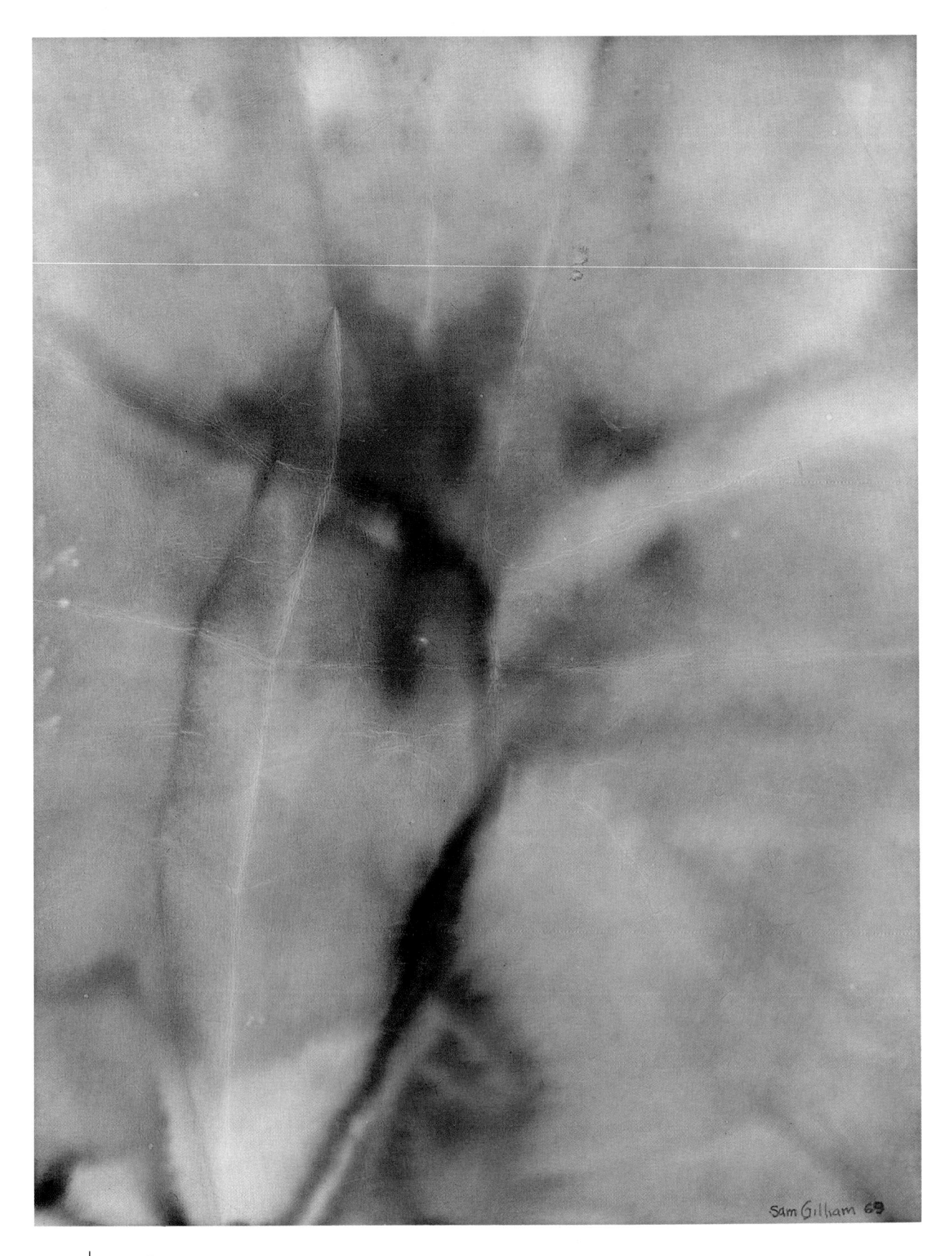

Fig. 54 | **Sam Gilliam**
Abstraction
acrylic on aluminum-treated paper
1969
cat. 48

Fig. 55 | Sylvia Snowden
Mamie Harrington
acrylic on masonite
1985
cat. 62

preted into a contemporary idiom. *Music Lesson* (1962; fig. 56) has a serenity of the pastoral landscapes of Giorgione or Titian. The resulting clarity of design and geometricized landscape is credited to his study of the old masters first-hand at the Louvre while living in Paris in 1961. Eventually, Thompson's paintings become symbolically dark and overtly sexual, reflecting the influence of Goya's paintings, which Thompson had seen while living in Spain during 1963.[10] Thompson foretold a newfound aesthetic that would be seen in subsequent African-American paintings and drawings as in the works by Robert Colescott and Robert Reed.

During the 1960s, many black artists found a comfortable spot in the abstract fold. Social concerns, however, were by no means passe and in fact found new vigor in the changed political climate. Just as the hopes fueled by the early civil rights movement had led to the formation of Spiral early in the decade, the disappointments of the mid-1960s gave rise to black nationalism, and eventually to the founding of a new, more militant group of black artists, AfriCobra.

While many artists were vociferous in laying their claim to pursue any art style, still others were equally concerned with the discovery of a true African-American aesthetic. Alain Locke's philosophy that African Americans must study and extract stylistic elements of African art, and incorporate them into their own work, came full circle in the late 1960s and early 1970s. The discussion over the definition and description of a black art became paramount among art historians and critics; it paralleled the defense of black culture and the rejection of racial integration as a panacea for black problems. Integration meant the denial of one's culture in acceptance of the mainstream, i.e., Euro-American culture. Many artists believed that following mainstream art styles meant creating an art which did not "speak" to a black audience. Such artists felt that the modern axiom "art for art's sake" was invalid. Instead, they adopted the tenet "art for the people." Often the tone was didactic, arrogant, and aggressive.

> Black art, like everything else in the Black community, must respond positively to the reality of revolution. It must become and remain a part of the revolutionary machinery that moves us to change quickly and creatively. We have always said, and continue to say, that the battle we are waging now is the battle for the minds of Black people.... It becomes very important then, that art plays the role it should play in Black survival and not bog itself down in the meaningless madness of the Western world wasted. In order to avoid this madness, Black artists and those who wish to be artists must accept the fact that what is needed is an aesthetic, a Black aesthetic, that is a criteria for judging the validity and/or the beauty of a work of art.[11]

As a response to the co-option of black art by white art critics and art historians, there began two phenomena in the late 1960s and early 1970s: the establishment of black museums and a proliferation of art exhibitions about African-American art. This was a time for artist coalitions, the rise of black women artists, and the establishment of numerous galleries in city neighborhoods. There was the Black Emergency Cultural Coalition, Weusi (based in Harlem), Art West Associated North (a conference of Southern California artists founded by E.J. Montgomery), the Nyumba Ya Sanaa Gallery in New York, the Studio Museum in Harlem, the Museum of the National Center of Afro-American Artists in Boston, and the proliferation of murals in major cities that depicted black heroes and history.

Spiral also continued to be a force; in these years, it intensified Richard Mayhew's sense of the

Fig. 56 | **Robert Thompson**
Music Lesson
oil on canvas
1962
cat. 56

Fig. 57 | **Irene Clark**
| *African Jail*
| oil on paper
| 1970
| cat. 45

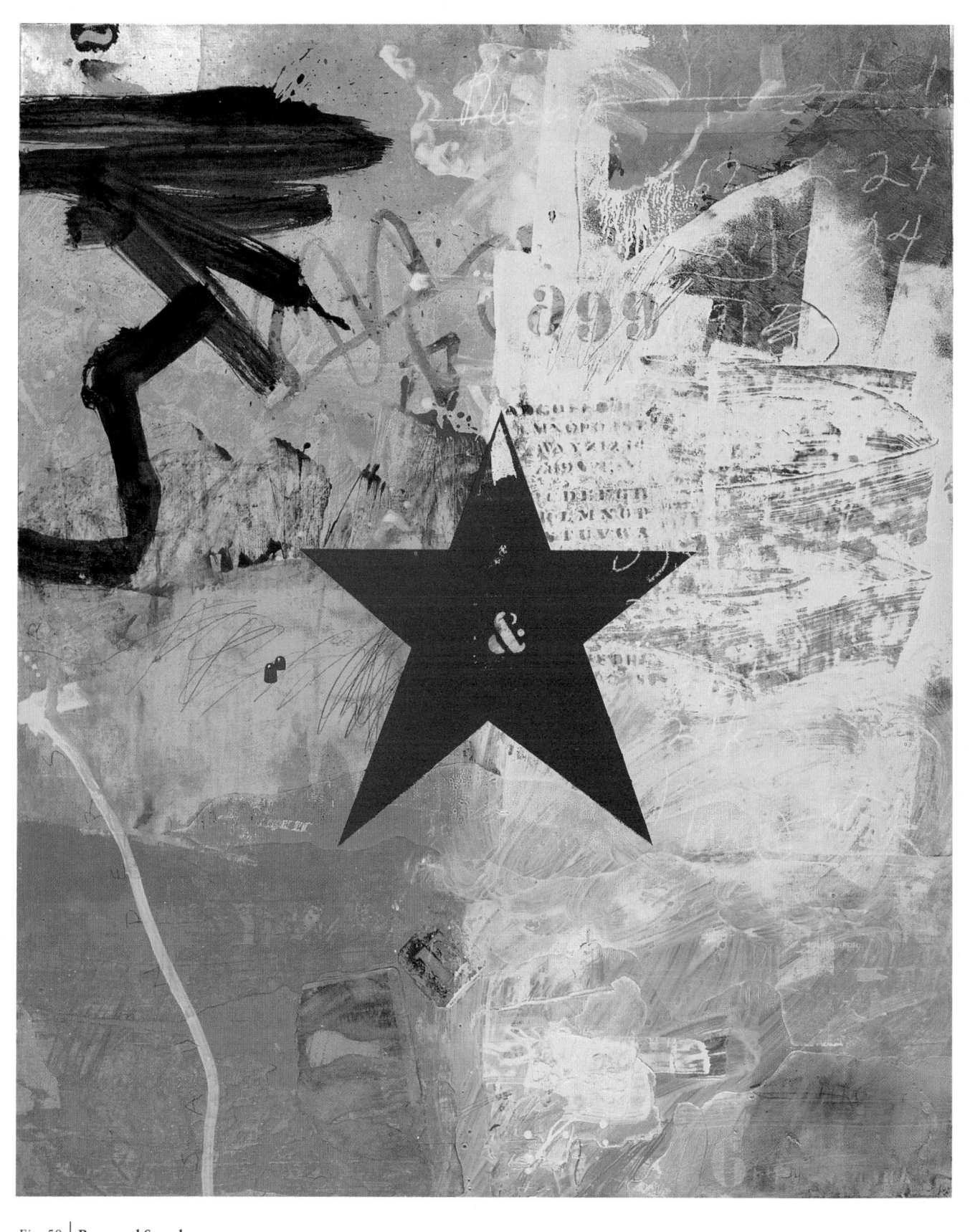

Fig. 58 | **Raymond Saunders**
Red Star
oil on canvas
1970
cat. 39

need for community. During the 1970s, he began to organize a variety of communal experiences such as a collective presentation of dancers, musicians, and slides of artwork for multi-media performances. These were held at Hunter College (1971-1975) in the combined arts program, then later Pennsylvania State University (1977-1978).

Between 1966 and 1973 there were thirty major exhibitions of African-American art. The rest of the 1970s, however, were disappointing. There was less than enthusiastic institutional sponsorship of exhibitions, many galleries and artist groups dissolved, and artists often "disappeared."

Frank E. Smith (b. 1935) and Raymond Saunders (b. 1934) represent the two distinct points of view that animated the 1960s and 1970s. One is ethnocentric, the other apolitical; yet, both artists prefer abstract styles over realism.

Raymond Saunders rejects the deliberate search for an identifiable black art aesthetic. In *Black Is A Color* (a small pamphlet that Saunders published in California, ca. 1968), he expressed the sentiments of many artists whose works are not recognizable as being done by a black artist.

Art projects beyond race and color; beyond America. Counter-racism, hyper-awareness of difference of separateness arising within the black artist himself, is just as destructive to his work, and his life—as the threat of white prejudice coming at him from outside.

Certainly the American black artist is in a unique position to express certain aspects of the current American scene, both negative and positive, but if he restricts himself to these alone, he may risk becoming a mere cypher, a walking protest, a politically prescribed stereotype, negating his own mystery, and allowing himself to be shuffled off into an arid overall mystique. The indiscriminate association of race with art, on any level—social or imaginative—is destructive.

In America, black is bound to black not so much by color or racial characteristics, as by shared experience, social and cultural.[12]

Works such as Saunder's *Red Star* (1970; fig. 58) are tableaux for personal identity. They do not address some grand social agenda. Yet Saunders reflects his environment, his experiences. The source is not Africa, but the urban streets, and the black ethos percolates to the surface. Saunders' paintings are formal replicas of the graffiti-scruffed walls of urban ghettos, in the seemingly uncontrived, haphazard application of paint, in the scrawled, painted lines, in the splattered and scraped surfaces, and in the stencilled letters that belie the puns or sarcasms about American society.

In 1973, Frank E. Smith joined one of the most pivotal artist coalitions of the twentieth century—the African Community of Bad Relevant Artists, or AfriCobra. Founded in Chicago by Jeff Donaldson (who later became chair of the art department at Howard University), AfriCobra strove to establish a contemporary black aesthetic derived from traditional African art and African-American culture. Its primary objective was to infuse the black community with renewed self-identity.

That AfriCobra still exists attests to its tenacity and viability within the black community. The organization has a compelling ideology which seeks to make the connection between music and color. The late Larry Neal stated that these "artists attempt to stretch and extend their use of colors across the full range of the spectrum much like Coltrane attempting to squeeze a multiplicity of tonal patterns and texture out of every note played on the saxophone. Colors are units of energy." AfriCobra seeks an artistic collectivism.

The works of AfriCobra are created according to several principles: "Free Symmetry," meaning rhythmic syncopation in design, music, and movement; "Shine," meaning luminosity through dynamic contrasts of color, form, and spacial rela-

Fig. 59 | **Frank E. Smith**
| *River of Darkness*
| *acrylic and ink on paper*
| *1986*
| *cat. 53*

Fig. 60 | **Ed Clark**
| *untitled*
| *etching*
| *about 1978*
| *cat. 66*

WHEN YOU THINK YOU'VE REACHED ONE PLACE IN LIFE YOU FIND THE SOUL HAS TAKEN YOU SOMEWHERE ELSE. B

Fig. 61 | **Robert Dillworth**
Abstractions
pencil on paper
1979
cat. 47

tionships; "Jam-packed and Jelly-tight Compositions," meaning form-filled and full-field surface design; "Awesome Imagery"; and "Koolaid Color."

In *River of Darkness* (1986; fig. 59), Smith is the inheritor of Alain Locke's idea that African textile patterns could be used as a structural base for painting. Irregular patches of color are combined with regularized motifs and asymmetrical compositions, common in African weavings and African-American quilts. Asymmetry of design and color creates a rhythmic syncopation analogous to music, especially jazz. Smith's primary concerns are color and pattern as visual archetypes relating to black culture. "What I do is improvise, an approach the way a jazz musician approaches it.... I am trying to create a jazz equivalent in the visual."[13] In its pictorial structure of a vertical, mathematical grid, *River* is non-control within a controlled structural element, the way improvisation exists within the underlying melodic structure of jazz.

Aside from groups and coalitions, many black artists choose alternate, highly original routes. In the search for an individual aesthetic, they explore process and technique, eventually arriving at a personal art, sometimes informed by abstraction, sometimes not. The untitled work (1978; fig. 60) by Ed Clark (b. 1926) mimics the artist's larger canvases with their varied bold strokes of transparent harmonious colors. Robert Dillworth (b. 1951) in *Abstractions* (1979; fig. 61) explores technique and the visual elements of shapes and space in his use of numbers and Greek letters that dissolve and emerge within the background of subtly modulated grey areas.

The untitled work (1977; fig. 62) by Howardena Pindell (b. 1943) marks a shift from her figurative paintings of the late 1960s. Into the 1970s, she assembled small dots of paper, creating subtly textured and delicate images. These works on paper were "a dig at the conceptual stuff that was going on then, especially at those people utilizing structural psychology" who wanted "a very elaborate psychological rationale for their work.... [They] had a meditative quality. I enjoyed the physical labor and the craftsmanship and the sense of abandonment or non-decision."[14] Within a few years, Pindell relinquished the methodically controlled process of her "dot" paintings for the asymmetry and documentation of personal experiences, particularly her travel to Japan and India, and the reality of being a black woman.

For others, the search relied upon natural surroundings or spiritual introspection. Considered "naive," both Joseph Yoakum (1886-1972) and Sister Gertrude Morgan (1900?-1980) were self-taught artists. Yoakum's world consisted of immense panoramas of nature, as in *Mount Siple in Ellsworth Highland District of Antarctica Island of South Pole Location* (1970; fig. 63). And Morgan found inspiration through religion, as in *God's Greatest Hits* (1979; fig. 64).

Louis Delsarte's *Ocean of Time* (1977; fig. 65) is a surreal vision of the world. Delsarte describes his style at that time as romantic expressionism. Birds, the ocean, and the female figure are rendered as personal symbols of flight, time, and security. Delsarte edited and diluted—yet at the same time acknowledged—the artistic principles of AfriCobra, the members of whom he met while an artist-in-residence at Howard University in 1983. Like the works of AfriCobra, forms, lines, and patterns fill the pictorial surface in patterns that are

Fig. 62 | **Howardena Pindell**
untitled
mixed media on matboard
about 1977
cat. 68

Fig. 63 | **Joseph Yoakum**
Mount Siple in Ellsworth Highland District of Antarctica Island of South Pole Location
colored pencil, pen and ink on paper
1970
| cat. 58

Fig. 64 | **Sister Gertrude Morgan**
God's Greatest Hits
tempera on paper
1978
cat. 50

Fig. 65 **Louis Delsarte**
Ocean of Time
pencil on paper
1977
cat. 63

Fig. 66 | **Barbara Tyson-Mosley**
Infant Garment
mixed media
1987
cat. 51

rhythmic. His paintings, unlike his graphite drawings, pulsate with clear, brilliant colors. He stated:

> My approach to art is greatly influenced by my heritage as an African American. The images and subject matter reveal black images, but in many cases I try to make these images universal. The everyday world, the one you read about in the paper and see on the television, is filled with confusion, chaos, and hate. What I try to show in my work is what I feel within, the ideals of higher truth and peace.[15]

The concept of ceremonial object, ritual, and magic transforms mundane materials into culturally significant objects; such items are mnemonic. Betye Saar (b. 1929) and Barbara Tyson-Mosley (b. 1950) create personal icons whose meanings exist within the black collective unconscious and the realm of autobiography. In Tyson-Mosley's *Infant Garment* (1987; fig. 66), the manipulation of cloth and other materials resemble traditional African amulets or fetishes.

Betye Saar transforms textural collage and assemblage into precious memorabilia and personal talismans. Saar's shift in subject matter from the occult to ritual and spiritual powers came partly out of her interest in traditional African art. By the mid-1970s, Saar was working with materials imbued with power, objects accrued with spiritual significance because of their previous owners.

Dat Ol' Black Magic (1981; fig. 67) has direct connections to Saar's life and memory. In 1975, the death of her Aunt Hattie caused Saar to produce a series of nostalgic pieces that contained the remnants of Hattie's life, such as the handkerchief. These collage/assemblages combine soft textures with bright colors and clearly defined images. Saar's works are affirmations of history and memory which reinforce and sustain African-American culture.

The late 1970s lacked the political momentum and social concerns that had animated the previous two decades. The 1980s, however, saw a revitalization of black visual arts through critical and institutional support. African-American museums were founded in Philadelphia, Los Angeles, and Denver. There were major retrospective exhibitions of groups of black artists as well as of individuals.

Coincidentally, major white institutions were sponsoring such exhibitions. The 1980s have been a time marking co-option and appropriation of black culture by Euro-American society.

Meanwhile, the search for an identity goes on among many African-American artists. But "identity," in the 1980s, often means ignoring superficial "isms" and artistic categories, as were prevalent in previous decades, and instead exploring, redefining, and asserting collective culture and society through the personal perspective of the individual.

The 1990s portend challenge for black artists, but one which—given the history of African-American art and artists—will be more than adequately met and reshaped as part of a continuing process of defining the self through the visual arts.

Betye Saar
Dat Ol' Black Magic
mixed media
1981
cat. 61

Fig. 68 | **Ulysses Marshall**
Sunshine Meets the Man
acrylic and collage
1980
cat. 67

NOTES

1. Alain Locke in *The New Negro* (New York: Albert and Charles Boni, 1925; repr. New York: Atheneum Press, 1970), which includes "The Legacy of Ancestral Arts," and *The Negro in Art* (Washington, D.C.: The Associates in Negro Folk Education, 1940) argues for an African-American art developed upon the foundation of the formalism of traditional African art. James Porter in *Modern Negro Art* (New York: Dryden Press, 1943; repr. New York: Arno Press, 1969) did not propose any established aesthetic, but the underlying message was that art should not seek a specific racial or ethnic identity. Eventually Porter in "One Hundred Fifty Years, Afro-American Art," in Wight, Frederick S., *The Negro in American Art* (Los Angeles: U.C.L.A. Art Galleries, 1966) acknowledged the worth of the New Negro Movement. For an excellent analysis of these two scholars and their philosophies, see Morrison, Keith, *Art in Washington and its Afro-American Presence: 1940-1970* (Washington, D.C.: Washington Project for the Arts, 1985), 23-36.

2. Bontemps, Arna, *Forever Free: Art by African American Women, 1862-1980* (Normal, IL: The Center for the Visual Arts Gallery, Illinois State University, 1980), 68.

3. The Studio Museum in Harlem, *Tradition and Conflict, Image of a Turbulent Decade, 1963-1973* (New York: The Studio Museum in Harlem, 1985), 13.

4. One of the important meeting places was Studio 35. Lectures by Rothko, Motherwell, and others attracted art historians, critics, and philosophers. After the school closed in 1949, three New York University professors took it over: Robert Iglehart, Tony Smith, and Hale Woodruff. It closed for good in 1950.

5. The Studio Museum in Harlem, *Hale Woodruff, 50 Years of His Art* (New York: The Studio Museum in Harlem, 1979), 36.

6. The fifteen artists in Spiral were Romare Bearden, Norman Lewis, Felrath Hines, James Yeargens, Charles Alston, Hale Woodruff, Richard Mayhew, Earl Miller, William Majors, Reginald Gammon, Calvin Douglass, Emma Amos, Merton Simpson, Alvin Hollingsworth, and Perry Ferguson.

7. Foresta, Merry A., *A Life in Art: Alma Thomas 1891-1978* (Washington, D.C.: National Museum of American Art, 1981), 24. Thomas graduated from Howard University in 1924. Other notable black artists studied at Howard as well, including David C. Driskell, Elizabeth Catlett, Delilah Pierce, Lucille (Malkia) Roberts, Ellis Wilson, and Sylvia Snowden.

8. Bontemps, Arna, ed. *David C. Driskell* (Normal, IL: The Center for the Visual Arts Gallery, Illinois State University, 1979), 5.

9. Morrison, *Art in Washington*, 59. For information in the following paragraph and the most insightful analysis of Gilliam vis-a-vis other black artists in Washington, see 57-60.

10. For the best analysis of Thompson's works at this time, see Wilson, Judith "Bob Thompson's *Beauty and the Beast*," in Hatch, James and Billops, Camille, *Artist and Influence 1988*, *Images of Women* vol. VI (New York: Hatch-Billops Collection, Inc., 1988), 55-66.

11. Karenga, Ron, "Black Cultural Nationalism," in Gayle, Addison, ed. *Black Aesthetic* (Garden City, N.J.: Doubleday, 1971), 32.

12. Saunders, Raymond, *Black Is A Color* (Oakland, CA: self-published, n.d.), 5-7.

13. Personal communication with the artist, October 1988.

14. Jacobs, Joseph, *Since the Harlem Renaissance* (Lewisburg, PA: The Center Gallery of Bucknell University, 1984), 36.

15. Personal communication with the artist, November 1988.

EXHIBITION CHECKLIST AND ARTIST BIOGRAPHIES

CHARLES ALSTON

Fine artist, illustrator, and teacher, Charles Alston (1907-1977) headed up the very influential Harlem Art Workshop in the mid 1930s, which spawned such talents as Jacob Lawrence, Robert Blackburn, and Georgette Seabrook Powell. Throughout Alston's life, he kept a careful balance between his role as an art educator and as a painter. Alston moved with fluidity between the figure and abstraction, although his coming-of-age during the impressionable years of the Works Progress Administration's Federal Arts Projects certainly oriented him toward more social objectives for his art.

Girl in a Red Dress
Oil on canvas, 1934
28" x 22"
Cat. 16, fig. 24

EDWARD MITCHELL BANNISTER

Born in St. Andrews, New Brunswick, Edward Mitchell Bannister (1828-1901) settled in Boston in the mid-nineteenth century where he studied at Lowell Institute with sculptor William Rimmer. After moving to Providence, Rhode Island, Bannister came into prominence in artistic circles in both cities. Although his painting *Under the Oaks* was awarded the bronze medal at the Philadelphia Centennial in 1876, Bannister seldom received the critical attention he deserved. Only a handful of Bannister's paintings depicted blacks, and most of his works portrayed the New England landscape in a style influenced by the Barbizon school.

Landscape with a Boat
Oil on canvas, 1898
6"x 9"
Cat. 2, fig. 1

RICHMOND BARTHÉ

In 1924, New Orleans-based artist Richmond Barthé (b. 1901) moved to Chicago, where he began a course of study at the School of the Art Institute. Within several years, he had had a successful solo exhibition in that city and had received the prestigious Julius Rosenwald Fellowship, which sponsored his first trip to New York City in 1929. It was around this time that Barthé decided to move to New York and focus primarily on sculpture. From portraits of famous actors to racial allegories, Barthé's award-winning work pays homage to the realist tradition in sculpture, which has historically served the needs of patrons from both the private and public sectors.

Portrait of Harold Jackman
Charcoal and pastel on paper, 1929
15½" x 12½"
Cat. 38, fig. 16

ROMARE BEARDEN

Although Romare Bearden (1914-1988) was known as one of the best practitioners of the art of contemporary collage, he began making collages relatively late in his career. Prior to this, he made watercolors and painted in oils. Always outspoken on the status of the African-American artist, Bearden wrote numerous articles about black artists and was a frequent lecturer on the subject. Although the themes of many works are often obscured by a dazzling technique, Bearden's art is rich in historical material and cultural truths—aspects of his art which demonstrate the interconnectedness between form, content, and context.

The Family
Watercolor and gouache on paper, 1948
25½" x 19½"
Cat. 17, fig. 36

GRAFTON TYLER BROWN

Grafton Tyler Brown (1841-1918) divided his time between painting and printmaking, making his living at the latter. Residing in California and the Pacific Northwest, Brown was interested in portraying the beauty of the landscape. His style was very naturalistic; more precise in detail than expressive in the use of both mediums. Later in his life, Brown chose to supplement his income by applying his printmaking skills to engineering and geological science. He died in St. Paul, Minnesota.

Yosemite Falls
Oil on canvas, 1888
30" x 18"
Cat. 1, fig. 3

The Iron-Clad Mine
Lithograph, about 1880
14½" x 18½"
Cat. 14, fig. 2

MARGARET BURROUGHS

Margaret Burroughs (b. 1917) has been at the helm of artistic activities in Chicago since the 1930s. Years spent working at the Southside Community Art Center and later at the DuSable Museum have shifted her approach on various subjects toward humanitarian issues. Her travels to Mexico, the Soviet Union, and throughout Africa have instilled in her a deep appreciation for the figure and for an art of social responsibility. Although well known for her paintings and prints, Burroughs is also a distinguished author of children's books, an honored educator, and an effective arts administrator.

Still Life
Oil on canvas, about 1943
19½" x 15½"
Cat. 18, fig. 30

ELIZABETH CATLETT

Born in Washington, D.C., sculptor, painter, and printmaker Elizabeth Catlett (b. 1915) studied at the Art Students League in New York, Howard University, the University of Iowa, and the Art Institute of Chicago, among other institutions. An active participant in the civil rights movement, Catlett has produced work concerned with social need. Early in her career, Catlett moved to Mexico where she has drawn inspiration from the social climate as well as the country's great artistic masters. As a black artist in the Mexican environment, Catlett has culled qualities of both cultures into a highly original body of work.

Sharecropper
Woodcut, 1970
19½" x 18½"
Cat. 65, fig. 46

ED CLARK

Born in New Orleans, Ed Clark (b. 1926) has spent his career in New York City. He studied at the Art Institute of Chicago and at the Academie de la Grande Chaumière in Paris. He has exhibited in many major U.S. cities and is represented in several collections around the world, including Boston's Museum of Fine Arts, Paris' Salon d'Autome, New York's Studio Museum in Harlem and the Whitney Museum, and in Washington, D.C. at the Hirshhorn Museum and Sculpture Garden.

Untitled
Etching, about 1978
36" x 49" framed
Cat. 66, fig. 60

IRENE CLARK

Born in Washington, D.C., painter, designer, and gallery director Irene Clark (b. 1927) studied at the Art Institute of Chicago. She has exhibited at the Oakland Museum, Howard University Gallery of Art, and Atlanta University. Clark's work relics primarily on folklore for subject matter. She transforms narrative stories into almost surreal visual events that unfold within her compositional spaces.

African Jail
Oil on paper, 1970
8" x 10"
Cat. 45, fig. 57

ELDZIER CORTOR

Eldzier Cortor (b. 1916) predates subsequent generations of African-American artists who sought out the roots of black art and culture via travels throughout the black diaspora. Cortor's time spent in the South Carolina Sea Islands and in Jamaica, Cuba, and Haiti all contributed to an already expanded vision of black humanity in his art. Born in Richmond, Virginia, Cortor spent his formative years in Chicago, and his mature years in New York. Cortor's travels, coupled with his studies at the Art Institute of Chicago and Columbia University, helped set the stage for what Richard Long has described as Cortor's artistic mantle of "naturalist/surrealist."

Man with a Sickle
Colored pencil, watercolor, pen and ink on paper, about 1945
10″ x 13″
Cat. 19, fig. 28

MARY REED DANIEL

Born in East St. Louis, Illinois, Mary Reed Daniel (b. 1946) achieved her artistic training at Southern Illinois University. In 1978, she received the Milliren Corporation of New York Purchase Award. Daniel is represented in the collection of the Smithsonian's National Museum of American Art. She has exhibited nationally and internationally.

Nature Study No. 20
Acrylic on paper, 1980
23″ x 20″
Cat. 46, fig. 50

BEAUFORD DELANEY

Although Beauford Delaney (1901-1979) studied at the South Boston School of Art, the Massachusetts Normal School, and the Copley Society in his youth, his mature work hardly reveals any of this early training. Rather, his paintings subscribe to the expressionist sensibilities of the New York art scene at mid-century, as well as to the free jazz temperaments of post-World War II black America. Upon Delaney's arrival in Paris in 1935, he joined a cadre of other African-American artists and intellectuals (James Baldwin, Richard Wright, Chester Himes, et. al.) who also sensed that the Parisian atmosphere would be more supportive of their art than the American artistic climate.

Untitled
Oil on canvas, 1946
17½″ x 21″
Cat. 20, fig. 37

LOUIS DELSARTE

Louis Delsarte (b. 1944) attended Pratt Institute, the University of Arizona, and the Bob Blackburn Printmaking Workshop in his home town of New York. He was the recipient of a National Urban League award, and has been artist-in-residence at Howard University and The Studio Museum in Harlem.

Ocean of Time
Pencil on paper, 1977
29½″ x 35½″
Cat. 63, fig. 65

RICHARD W. DEMPSEY

Born in Ogden, Utah, Richard W. Dempsey (1919-1987) was an active participant in the Washington, D.C., art scene, having made his home in Takoma Park, Maryland. He studied at the California College of Arts and Crafts, the Art Students League, and under artist Sargent Johnson. For his work he received awards from The Corcoran Gallery of Art, the Julius Rosenwald Fellowship, the U.S. Army Historical Center, and the District of Columbia. He had exhibitions at numerous Washington galleries as well as other institutions around the world.

Cityscape
Oil on board, 1955
11″ x 13½″
Cat. 43, fig. 40

North Carolina
Watercolor, 1965
22″ x 30½″ framed
Cat. 60, fig. 41

JAMES VAN DERZEE

Although photographer James Van DerZee (1886-1983) maintained a commercial studio in New York City for almost fifty years, it was not until his work appeared in the Metropolitan Museum of Art exhibition *Harlem on my Mind* that his reputation soared among collectors of vintage American photography. Largely self-taught, Van DerZee was Harlem's premiere chronicler in the years between 1920 and 1940. While the bulk of Van DerZee's work consists of studio portraiture, some of his most important images document groups of individuals and organizations, such as A'lelia Walker's Beauty Parlor League and Marcus Garvey's University Negro Improvement Association, for which Van DerZee was official photographer.

Alpha Phi Alpha Basketball Team
Photograph, 1926
9½″ x 7″
Cat. 32, fig. 17

ROBERT DILLWORTH

Born in Lawrenceville, Virginia, Robert Dillworth (b. 1951) studied at the Rhode Island School of Design, Yale University, the Art Institute of Chicago, and in Florence, Italy, at the Academia de Belle Arte. His exhibition locations include the Chicago Cultural Center, the University of Illinois, the Afro-American Museum of Art in Dallas, Texas, and the J.B. Speed Museum in Louisville, Kentucky.

Abstractions
Pencil on paper, 1979
24½″ x 34½″
Cat. 47, fig. 61

AARON DOUGLAS

Aaron Douglas (1899-1979), along with Langston Hughes, James Weldon Johnson, Countee Cullen, and others, have come to epitomize the artists of the Negro Renaissance period. Douglas' arrival in New York City in the mid 1920s was timely, for it coincided with the promotion of black literary, theatrical, musical, and visual art talents by such organizations as the Harmon Foundation and the N.A.A.C.P. It was also at this time that Douglas came under the tutelage of artist/designer Winold Reiss, whose Art Deco formulas and interest in African art channeled Douglas' thinking toward a truly modern, black approach to art. A professor of art at Fisk University for twenty-nine years, Douglas shared his insights on art and culture with several generations of students.

Aspiration
Oil on canvas, 1936
60″ x 60″
Cat. 21, fig. 23

DAVID C. DRISKELL

Presently a professor of art at the University of Maryland, David C. Driskell (b. 1931) is an articulate spokesman for black art. In 1962, he was the winner of the Museum Donor Award presented by the American Federation of Art and has taught at the Institute for African Studies of the University of Ife in Nigeria. While in Africa, Driskell worked with many well-known artists from that continent. Much of his work is derived from African roots and often combines the concerns of abstraction with more social considerations and figurative elements. Driskell has stated that his "art seldom imitates literal life, but it does imitate the ways of life."

Movement, The Mountain
Egg tempera on canvas, 1980
31″ x 22½″
Cat. 44, fig. 53

SAM GILLIAM

A younger son of the Washington Color School, Sam Gilliam (b. 1933) has worked in many mediums and often produces work that bridges the gaps between materials, such as suspended paintings and painted sculpture. He is known particularly for his highly original manipulation of materials. Among his awards are two grants from the National Endowment for the Arts and participation in the thirty-sixth Venice Biennale. Gilliam lives and works in Washington, D.C.

Abstraction
Acrylic on aluminum-treated paper, 1969
23½″ x 18″
Cat. 48, fig. 54

REX GORLEIGH

As with many New York artists in the 1920s and 1930s, Rex Gorleigh (1902-1987) first exhibited his work in the non-juried shows organized by the Society of Independent Artists. Indeed an "independent," Gorleigh received his art education from a variety of sources, including the Art Students League and, later, artist André Lhote in Paris. Despite Gorleigh's own casual attitude about formal art training, he taught art at several schools, among them Palmer Memorial Institute in Sedalia, North Carolina, and Chicago's Southside Community Art Center.

Planting
Watercolor and tempera on paper, 1943
15½″ x 14¼″
Cat. 22, fig. 35

WILLIAM HARPER

Born in Canada, William Harper (1873-1910), along with William Edouard Scott, studied at the Art Institute of Chicago and under Henry O. Tanner in Paris. One of the first artists to contribute to a Harmon Foundation exhibition, Harper was enthusiastic about what would soon become the Negro Renaissance. Considered one of the most gifted black artists at the turn of the century, Harper's untimely death offers only a hint at his developing talents. Influenced by the artists of the Barbizon school, Harper's mature landscapes surpassed the more traditional works of Tanner.

Patio
Oil on canvas, 1908
15½″ x 21½″
Cat. 4, fig. 12

PALMER HAYDEN

In 1926, Palmer Hayden (1893-1973) was the first recipient of the Harmon Foundation's Gold Medal for distinguished achievements by a black in the fine arts field. Shortly after receiving this honor, Hayden left New York for an extended stay in Paris. Upon his return in 1932, he worked at a number of odd, part-time jobs in order to have sufficient time to paint. One of the high points in his career—a series of paintings recounting the exploits of American folk hero John Henry—represents an interesting juncture for Hayden, since the series combines narrative elements, an expressionist painting technique, and direct corollaries to American folklore.

Café L'Avenue
Watercolor on paper, 1932
9½″ x 7½″
Cat. 23, fig. 18

RICHARD HUNT

Born in Chicago, sculptor and printmaker Richard Hunt (b. 1935) is considered one of America's leading sculptors of metal. Early in his career, Hunt worked under Spanish artist Julio Gonzales who was among the first to devise the welded-iron technique. Hunt's work is abstract, yet often incorporates figurative or organic forms. His work has been shown all over the world.

Extensions
Colored lithograph, 1983
42″ x 30″
Cat. 49, fig. 49

CLEMENTINE HUNTER

Clementine Hunter (1885-1988) first came to the public's attention with exhibitions of her paintings at major galleries and museums in the 1950s. By this time, she was well into her sixties, having spent her entire life picking cotton and doing domestic work in and around the small town of Natchitoches, Louisiana. As with many self-taught artists, Hunter began making art in her later years, with the encouragement of local art professionals and semi-professionals.

The Pole Watchers
Tempera on cardboard, about 1948
13½″ x 12″
Cat. 24, fig. 33

SARGENT JOHNSON

Sargent Johnson (1888-1967) was a pioneering black modernist from Berkeley, California. As early as 1925, Johnson received praise for his wood, cast stone, and ceramic sculpture. Like many black artists of his generation, he frequently entered art competitions sponsored by the Harmon Foundation. One of his more famous pieces, a sculpture for San Francisco's Golden Gate Exposition Park of 1939, is generally regarded as one of the outstanding examples of federally-funded, public art in California. Most of his smaller, figural sculptures reveal his adherence to an aesthetic of classic, mask-like forms and recognizable Negro subjects.

Singing Saints
Lithograph, 1940
13″ x 10″
Cat. 25, fig. 27

LOIS MAILOU JONES

Although the career of Lois Mailou Jones (b. 1905) literally spans over sixty years, it is only as recently as 1973 that the artist was honored with her first major retrospective which took place at the Museum of Fine Arts in Boston. Prior to and since that honor, Jones has exhibited widely and has been the recipient of countless awards and accolades from museums and institutions of higher learning, as well as from the government of Haiti. Born in Boston, Jones studied at the Boston Normal Art School, the School of the Museum of Fine Arts in Boston, Columbia University Teachers College in New York, Howard University in Washington, D.C., and at the Academie Julien and the Ecole des Beaux Arts in Paris.

The Lovers (Somali Friends)
Casein on canvas, 1950
15″ x 18″
Cat. 26, fig. 26

JACOB LAWRENCE

In 1940, the precocious talents of the twenty-three-year old artist Jacob Lawrence (b. 1917) were known only by a handful of people beyond Harlem. But, as a result of his critically-hailed *Migration Series* (which was partially published in the November 1941 issue of *Fortune Magazine*), Lawrence had become the wunderkind of the art world. Numerous exhibitions and major museum purchases followed this early success, the most recent being the widely celebrated retrospective, *Jacob Lawrence, American Painter,* organized by the Seattle Art Museum. This exhibition featured a representative sampling of Lawrence's work, much of it concerned with African-American history and culture.

Graduation
Gouache on paper, 1948
25″ x 16½″
Cat. 27, fig. 38

HUGHIE LEE-SMITH

Born in Eustis, Florida, Hughie Lee-Smith (b. 1914) grew up in Atlanta and Cleveland before moving to New York. His parents greatly encouraged his artistic production, yet, having matured during a time when black critics and intellectuals refused to take art seriously, Lee-Smith initially lacked the recognition he deserved. Expressive of the dimensions of human experience through simple juxtapositions of characters and environments, Lee-Smith's works often convey a sense of desolation and alienation.

Reflection
Oil on canvas, 1957
23½" x 35½"
Cat. 54, fig. 43

ULYSSES MARSHALL

Upon returning from Vietnam in 1966, Ulysses Marshall (b. 1946) found the civil rights movement in full swing. In a body of work that often draws from these experiences, Marshall mixes the abstract with the figurative in a richly colored, yet confrontational manner. "My work is a reflection of my experiences both within the system and from its outside," Marshall states. "It is an echo from within a tunnel, not necessar[il]y without light—but a tunnel where seeing and feeling and touching is more important than getting through."

Sunshine Meets the Man
Acrylic and collage, 1980
29½" x 22½"
Cat. 67, fig. 68

RICHARD MAYHEW

Born in Amityville, Long Island, Richard Mayhew (b. 1934) studied art in New York City and in Florence, Italy. Primarily a landscape painter, Mayhew applies paint in a way similar to the impressionists. He is concerned with the play of light in real situations and the lyrical use of color in his compositions. His work "sums up, rather than represents, nature." Mayhew has had exhibitions in New York, as well as in Chicago, Pittsburgh, Los Angeles, San Francisco, Atlanta, and Boston.

Vibrato
Oil on canvas, 1974
29½" x 37½"
Cat. 40, fig. 48

LEV T. MILLS

Lev T. Mills (b. 1940) was born in Wakulla County, Florida. After graduating from the University of Wisconsin, he was awarded a Ford Foundation fellowship to study at the University of London's Slade School of Fine Arts and Atelier 17 in Paris. Mills is a graphic artist and printmaker, and harbors a special affinity for new materials and techniques. His subject matter is often concerned with the meaning of the black identity.

Gemini I
Etching, 1969
14" x 13"
Cat. 42, fig. 44

SISTER GERTRUDE MORGAN

Painter, singer, and preacher, Sister Gertrude Morgan (1900?-1980) was considered a naive or folk artist. Her work uses brilliant and vibrant colors to convey the vitality of her spirit. And her writings and gospel lyrics were often recycled as part of her graphic compositions. Her work has often been shown in and around her home of New Orleans, and she has also been exhibited nationally in exhibitions of folk artists.

God's Greatest Hits
Tempera on paper, 1978
8" x 4¾" x½"
Cat. 50, fig. 64

ARCHIBALD MOTLEY, JR.

Archibald Motley, Jr. (1891-1980) was primarily a genre painter of modern black life. Along with Palmer Hayden and Aaron Douglas, Motley chose to work in a less academic style in the search for an aesthetic informed of African history. In this, though, he chose not to glorify or idealize blacks and their activities. Receiving early encouragement in his career with an exhibition in New York in 1928, Motley was one of the first black American, beside Henry O. Tanner, to have a one-man exhibition in this country. Motley's paintings were often derived from African-American cultures, with intensely colored surfaces and images culled from urban sources.

After Fiesta, Remorse, Siesta
Oil on canvas, 1959-60
33" x 38"
Cat. 41, fig. 42

DELILAH PIERCE

Born in Washington, D.C., painter Delilah Pierce (b. 1904) studied at Howard University, Columbia University Teachers College, the University of Pennsylvania, and New York University, as well as under the tutelage of such artists as Lois Mailou Jones and James Lesesne Wells. She has exhibited her work at many locations, including The Corcoran Gallery of Art, the Baltimore Museum of Art, and the Smithsonian Institution.

Nebulae
Watercolor, 1982
29" x 22½"
Cat. 52, fig. 52

HOWARDENA PINDELL

Born in Philadelphia, painter and museum curator Howardena Pindell (b. 1943) studied at Boston and Yale Universities. She has exhibited at the Whitney Museum, A.I.R. Gallery in New York City, and at locations in Philadelphia and Paris. Her early figurative work gave way in the 1970s to a more process-oriented approach to art.

Untitled
Mixed media on matboard, about 1977
11¹⁵⁄₁₆" x 14"
Cat. 68, fig. 62

P.H. POLK

Photographer P.H. Polk (1898-1984) learned his craft from two early black photographers, C.M. Battey and Fred Jensen. In 1927, Polk opened his own photography studio in Tuskegee, Alabama. The following year he was appointed to the faculty of Tuskegee Institute, where he remained until his retirement some fifty years later. Although Polk was well known for some time among Tuskegee and African-American photography enthusiasts, it was not until a book of his most important photographs was published in 1980 that he received the national recognition which his work had so long deserved.

Lillian Evans Tibbs
Photograph, about 1937
11¼" x 8½"
Cat. 28, fig. 21

NELSON PRIMUS

Primarily a self-taught artist, Nelson Primus (1843-1916?) was a painter of portraits and religious subjects. Born in Hartford, Connecticut, Primus experienced modest acclaim in that city. In 1864, he moved to Boston where he found it difficult to survive. Although he befriended Edward Mitchell Bannister, Primus was unable to convince Bannister to allow him access to the artistic circles necessary to gain success. Unable to afford a much desired trip to Paris for study, Primus moved to San Francisco where his only support was found in the Chinese community. He died in the West at some point during the second decade of the twentieth century.

Portrait of a Lady (Lady with Golden Hair)
Oil on canvas, 1907
24" x 20"
Cat. 3, fig. 4

BETYE SAAR

Influenced by African-American folk culture and myths, Betye Saar (b. 1929) has used many found and earth-oriented materials, such as leather, wood, straw, and cloth. Much of her work is informed by the occult and astrology, as well as social and political concerns. In the late 1960s, Saar began to appropriate stereotypical portrayals of blacks into her artistic investigations. In these, she upsets mass-market images with situations that alter the interpretations of the original pictures. Historian Samella Lewis considers Saar interested in the "liberation of all Aunt Jemimas and Uncle Toms."

Dat Ol' Black Magic
Mixed media, 1981
14" x 12½"
Cat. 61, fig. 67

RAYMOND SAUNDERS

Raymond Saunders (b. 1934) merges figurative, geometric, and calligraphic styles in his work. He studied at the Carnegie Institute of Technology and the California College of Arts and Crafts and has shown at the San Francisco Museum of Art, the Museum of Modern Art, the Whitney Museum, the Minneapolis Institute of Art, and the Boston Museum of Fine Arts, among others. Known for his exuberant and personal handling of mediums, Saunders uses the pictorial plane as a space for the recording of ideas. Present in this process-oriented work are the traces of Saunder's artistic dialog. His works underscore the idea that the picture plane is merely a tool for exploring events and relationships.

Red Star
Oil on canvas, 1970
56" x 46"
Cat. 39, fig. 58

WILLIAM EDOUARD SCOTT

Like William Harper, William Edouard Scott (1884-1964) studied at the Art Institute of Chicago before traveling to Paris to study under the influential Henry O. Tanner. Best known for his portraits and murals, Scott valued the illustration of ideas over the academic painting of subjects. In 1931, he traveled to Haiti where a drastic change in his style took place; his palette became intensely colored and his brushwork more expressive. Scott was eventually one of the first black painters to discard the pressures of the European tradition.

Lagoon
Lithograph, 1912
7″ x 9″
Cat. 12, fig. 14

Old Woman
Lithograph, 1912
11″ x 8½″
Cat. 13, fig. 13

ADDISON SCURLOCK

Born in Fayetteville, North Carolina, Addison Scurlock (1883-1964) became an apprentice photographer at the Rice Studios in Washington, D.C. Within several years, he had begun his own photographic operations in Washington, doing commissioned work for Howard University, as well as for other institutions. In 1907, he received the Gold Medal for Excellence at the Jamestown Exposition. Almost seventy years later, he was posthumously honored with his first major retrospective at The Corcoran Gallery of Art in Washington, D.C.

Portrait of Mrs. Johnson
Photograph with highlights, 1905
17½″ x 14″
Cat. 11, fig. 15

Portrait of Madame Evanti (Lillian Tibbs)
Photograph, about 1934
11″ x 8½″
Cat. 29, fig. 20

CHARLES SEBREE

Charles Sebree (1914-1985) was one of many important black artists who were products of Chicago's little known but significant art scene of the 1930s. After receiving much recognition in various Chicago exhibitions, Sebree moved to New York in 1940, where he illustrated Countee Cullen's book *The Lost Zoo* and participated in several gallery and museum shows. In later years, Sebree was also involved in the theater, designing sets and even co-authoring a Broadway play, *Mrs. Patterson*. In the early 1960s, Sebree settled in Washington, D.C., where he was featured in exhibitions at Howard University, Barnett-Aden Gallery, Henri Gallery, and other art spaces.

Boy in a Blue Jacket
Oil on canvas, 1938
36″ x 29½″
Cat. 30, fig. 29

FRANK E. SMITH

A member of AfriCobra, printmaker and painter Frank E. Smith (b. 1935) produces brilliantly colored, abstract works that have their roots in African traditions. His images come from the West African patterns in fabric design and architectural detail all merged into the age-old African-American tradition of quiltmaking. A professor of art at Howard University, Smith is interested in work that is characteristically black American and Afrocentric in style.

River of Darkness
Acrylic and ink on paper, 1986
76″ x 36″
Cat. 53, fig. 59

SYLVIA SNOWDEN

Born in Raleigh, North Carolina, Sylvia Snowden (b. 1942) studied at Howard University, the Skowhegan School of Painting and Sculpture, and La Grande Chaumière in Paris. She presently makes her home in Washington, D.C., and has held exhibitions at Washington Project for the Arts, Zenith Gallery, and the Baltimore Museum of Art, and at the National Academy of Design in New York, among numerous others. Snowden's canvases are characterized by intensely colored and often murky surfaces of thickly impastoed paint.

Mamie Harrington
Acrylic on masonite, 1985
48½″ x 67″
Cat. 62, fig. 55

HENRY O. TANNER

Born the son of an African Methodist minister, Henry O. Tanner (1859-1937) produced paintings marked with religious expression. While attending the Pennsylvania Academy of the Fine Arts in Philadelphia, Tanner met Thomas Eakins. Frustrated by racial constraints, Tanner migrated to Europe. Settling in Paris, Tanner studied at the Academie Julien with Benjamin Constant and soon won many awards around the world for his paintings. Tanner lacked interest in the Negro Renaissance believing that his work should be considered without regard to his race. Nevertheless, he became a model for many younger black artists.

Head of a Girl in Jerusalem (The Artist's Wife)
Oil on artist board, 1899
12½″ x 10″
Cat. 5, fig. 5

The Good Shepherd
Oil on artist board, about 1918
23″ x 19″
Cat. 6, fig. 11

The Wreck (Shipwreck on the Coast of Brittany)
Etching, 1913
8″ x 10″
Cat. 7, fig. 9

Street Scene–Tangiers
Etching, 1913
8⅞" x 11¼"
Cat. 8, fig. 6

Gate–Tangiers
Etching, 1910
11⅞" x 9⅜"
Cat. 9, fig. 7

Christ Walking on the Water
Etching, 1910
9½" x 11"
Cat. 10, fig. 8

After the Storm
Oil on canvas, about 1880
18½" x 32½"
Cat. 15, fig. 10

ALMA THOMAS

Born in Columbus, Georgia, Alma Thomas (1894-1978) studied at Howard, Columbia, and The American Universities. Thomas began her career as a teacher in the D.C. public schools, choosing to become a full-fledged artist later in her life. She exhibited all over the United States and is represented in many collections, including the Metropolitan Museum of Art, the Smithsonian's National Museum of American Art and Hirshhorn Museum and Sculpture Garden, The Corcoran Gallery of Art, and the Phillips Collection. Thomas' work is characterized by the use of flat colors applied in homogenous strokes that establish the motion of the canvas. It is her physical application of paint and her use of pure color that is metaphor for the natural order of the landscape.

Leaves Outside a Window in Rain
Watercolor, 1966
19" x 24"
Cat. 55, fig. 51

ROBERT THOMPSON

An extremely prolific artist during his short lifetime, Robert Thompson (1936-1966) traveled throughout Europe to study classical traditions. Upon the techniques and styles he discovered there, Thompson would transpose his own unique sense of imagery. His paintings are characterized by the use flat areas of brilliant color to desribe forms. Thompson was interested in depicting inner feeling rather than objective form and commonly used nightmares and fantasies as subject matter in his work. Much of his work has been shown, posthumously, all over the world.

Music Lesson
Oil on canvas, 1962
47½" x 47½"
Cat. 56, fig. 56

BILL TRAYLOR

Born during America's last decade of legalized slavery, Bill Traylor (1854-1947) lived the majority of his life in and around Montgomery, Alabama. At the age of about eighty-five, Traylor started to put down on discarded boxes and cardboard a visual record of farm animals, wagons, people, and his vivid imagination in general. Further encouraged by local artist Charles Shannon, Traylor was given two exhibitions during this period: one in Montgomery and the other in New York City. Long after Traylor's death, his work was rediscovered and touted as some of the best work in the folk or "outsider" art genre.

Untitled *(Anthropomorphic Figure and Cat)*
Pencil on cardboard, about 1938-43
9" x 8¼"
Cat. 31, fig. 31

Untitled *(Woman with Purse)*
Tempera on cardboard, about 1938-43
10¼" x 6⅞"
Cat. 36, fig. 32

BARBARA TYSON-MOSLEY

Born in Harrisburg, Pennsylvania, Barbara Tyson-Mosley (b. 1950) resides in Washington, D.C. She completed her formal art education at the University of the District of Columbia and at Georgetown University and has shown her work at the Evans-Tibbs Collection Gallery, Market 5 Gallery, the Stewart-Mott Foundation, and the U.S. Department of the Interior.

Infant Garment
Mixed media, 1987
31½" x 23" x 4"
Cat. 51, fig. 66

LAURA WHEELER WARING

A student at the Pennsylvania Academy of Fine Arts in the late 1910s and early 1920s, Laura Wheeler Waring (1887-1948) was known especially for her portraiture "in the grand manner." After six years of study at the Pennsylvania Academy, she traveled to France, which she described as her "only period of uninterrupted life as an artist, with an environment and associates that were a constant stimulus and inspiration." Although she was to spend the majority of her time (from the mid 1920s until her death some twenty years later) in the vicinity of Philadelphia, her art bore the stamp of a chromatic and impressionistic "Ecole de Paris."

Still Life
Oil on canvas, 1928
41½" x 31½"
Cat. 33, fig. 19

JAMES LESESNE WELLS

James Lesesne Wells (b. 1902) came to artistic fruition in New York City and Washington, D.C. In New York, Wells showed at J.B. Neumanns' New Art Circle Gallery and sold block print illustrations to *New Masses, The Golden Book, Opportunity,* and *The Crisis.* In Washington, he taught for almost forty years in Howard University's art department, all the while continuing to paint and make prints. Wells' sixty years as a printmaker and painter of merit were celebrated recently in a major retrospective organized by the Washington Project for the Arts. Following its premiere there, the exhibition traveled to New York's Studio Museum in Harlem.

Negro Worker
Lithograph, 1945 (about 1938 original)
14⅞" x 10⅝"
Cat. 34, fig. 25

Escape of the Spies from Canaan
Linoleum cut print, about 1933
10½" x 13½"
Cat. 35, fig. 22

CHARLES WHITE

Painter and graphic artist Charles White (1918-1979) produced work that explores the souls of African Americans. White's early days in Chicago brought him together with soon-to-be influential artists Charles Sebree, Eldzier Cortor, and Archibald Motley, Jr. and writers Richard Wright, Gwendolyn Brooks, Willard Motley, and Lorraine Hansberry. Equipped with the techniques and discipline of traditional formats, White was an interpreter of black life through his depictions of idealized black heroes and the struggling black masses.

Sounds of Silence
Lithograph, 1978
27" x 36"
Cat. 64, fig. 45

WALTER H. WILLIAMS

Born in Brooklyn, New York, Walter H. Williams (b. 1930) is a painter and printmaker. Following his studies at the Brooklyn Museum of Art School and the Skowhegan School of Painting and Sculpture in Maine, Williams moved to Copenhagen, Denmark. He has shown his work in numerous locations, including New York, Philadelphia, Nashville, and Washington, D.C., in the United States, and in Mexico City, Copenhagen, Stockholm, Sydney, and other locations around the world.

Third Avenue El
Gouache on paper, 1955
18" x 23½"
Cat. 59, fig. 39

HALE A. WOODRUFF

Following studies at the John Herron Art Institute, artist Hale A. Woodruff (1900-1980) spent several important years in France. After mastering the techniques of such European moderns as Cézanne and Matisse, Woodruff returned to the United States where his works were shown in exhibits at the Downtown, Valentine, and Feragil Galleries in New York. In addition to a continuous exhibition record for the next fifty years, Woodruff taught art, first at Atlanta University and later at New York University. He founded the Atlanta University Annual Exhibition in 1942. After a period of studying fresco painting with Diego Rivera in Mexico, Woodruff created major murals on African-American themes for Talledega College, Atlanta University, and the Golden State Mutual Life Insurance Company.

Landscape
Oil on canvas, about 1936
36" x 30½"
Cat. 37, fig. 34

Caprice
Oil on canvas, 1962
33" x 45"
Cat. 57, fig. 47

JOSEPH YOAKUM

Born in Window Rock, Arizona, Joseph Yoakum (1886-1972) gained considerable recognition only after his death in Chicago. His work has been exhibited at Carl Hammer, Douglas Kenyon, and Wabash Transit Galleries in Chicago, the School of the Art Institute of Chicago, the Museum of Contemporary Art in Chicago, the Whitney Museum, and The Corcoran Gallery of Art, to name a few.

Mount Siple in Ellsworth Highland District of Antarctica Island of South Pole Location
Colored pencil, pen and ink on paper, 1970
12" x 18½"
Cat. 58, fig. 63

SELECTED BIBLIOGRAPHY

Bontemps, Arna. *Forever Free: Art by African American Women, 1862-1980*. Normal, IL: The Center for the Visual Arts Gallery, Illinois State University, 1980.

Coar, Valencia Hollins, ed. *A Century of Black Photographers*. Providence, RI: Rhode Island School of Design Museum of Art, 1983.

Dover, Cedric. *American Negro Art*. Greenwich, CT: New York Graphic Society, 1969.

Driskell, David C. *Two Centuries of Black American Art*. New York: Los Angeles County Museum of Art and Knopf, 1976.

The Evans-Tibbs Collection. "Grafton Tyler Brown, Nineteenth Century American Artist." Washington, DC: The Evans-Tibbs Collection, 1988.

Fine, Elsa H. *The Afro-American Artist: The Search for Identity*. New York: Holt, Rinehart & Winston, 1973.

Gaither, Barry. *Afro-American Artists, New York and Boston*. Boston: The Museum of the National Center of Afro-American Artists, 1970.

Hartigan, Lynda R. *Sharing Traditions: Five Black Artists in Nineteenth-Century America*. Washington, DC: Smithsonian Institution Press, 1985.

Igoe, Lynn M. *Two Hundred and Fifty Years of Afro-American Art: An Annotated Bibliography*. New York: R.R. Bowker, 1981.

Jacobs, Joseph. *Since the Harlem Renaissance*. Lewisburg, PA: The Center Gallery of Bucknell University, 1984.

Lewis, Samella. *Art: African American*. New York: Harcourt, Brace, Jovanovich, 1978.

Locke, Alain L. *Negro Art: Past and Present*. Washington, DC: Associates in Negro Folk Education, 1936.

Locke, Alain, ed. *The New Negro*. New York: Albert and Charles Boni, 1925; repr. New York: Atheneum Press, 1970.

Locke, Alain. *The Negro in Art: A Pictorial Record of the Negro Artist and of the Negro Theme in Art*. Washington, D.C.: The Associates in Negro Folk Education, 1940; repr. New York: Hacker Art Books, 1979.

Porter, James A. *Modern Negro Art*. New York: Dryden Press, 1943; repr. New York: Arno Press, 1959.

Porter, James A. "One Hundred Fifty Years, Afro-American Art." In Wight, Frederick S. *The Negro American in Art*. Los Angeles: U.C.L.A. Art Galleries, 1966.

The Studio Museum in Harlem. *The Harlem Renaissance*. New York: Harry N. Abrams, Inc., 1987.

The Studio Museum in Harlem. *Tradition and Conflict, Image of a Turbulent Decade, 1963-1973*. New York: The Studio Museum in Harlem, 1985.

Willis-Thomas, Deborah. *Black Photographers 1840-1940: A Bio-bibliography*. New York: Garland Publishing, Inc., 1985.

African-American Artists 1880-1987:
Selections from the Evans-Tibbs Collection

Prepared by the Smithsonian Institution Traveling Exhibition Service
Andrea Price Stevens, Publications Director
Edited by Dale E. Alward, SITES
Produced by Perpetua Press, Los Angeles
Designed by Dana Levy
Studio photography by Garry Garisson, Washington, D.C.
Typeset in Sabon
by Continental Typographics, Chatsworth, California
Printed by South Sea International, Hong Kong